ELECTRIC DREAMS

Every piece in this book has been created using
the Microsoft XP version of Paint and an optical mouse.

Please note that these images are the result of the bizarre and surreal
requests made to Jim'll Paint It. None of the ridiculous events
involving celebrities or brands depicted took place in this universe.

For Natalie

ELECTRIC DREAMS

THE COLLECTED WORKS OF

Jim'll Paint it

ff

FABER & FABER

First published in 2014
by Faber & Faber Ltd
Bloomsbury House
74–77 Great Russell Street
London WC1B 3DA

Typeset by Faber & Faber Ltd
Printed in China

The right of Jim'll Paint It to be identified as author
of this work has been asserted in accordance with Section 77
of the Copyright, Designs and Patents Act 1988

A CIP record for this book
is available from the British Library

ISBN 978-0-571-31555-0

2 4 6 8 10 9 7 5 3 1

INTRODUCTION

A lot's changed since I first used Microsoft Paint. I've more or less doubled in size, physically. New Labour came, became not-so-new and then went again. The internet started happening. Cassette tapes stopped happening. I finally moved out of my dad's house and Jif is now Cif. One of the few things that's stayed the same is Paint itself; a reassuring bastion of gawky rubbishness in an era of frightening perpetual change.

A common assumption is that I knowingly picked Microsoft Paint as a purposefully ironic, outdated medium. In truth, it was chosen because I feel comfortable with it and always have. There's something so intrinsically awkward about MS Paint that creating something that looks even remotely not-terrible feels like a triumph. I've never been able to shake the feeling that when I use actual paint or 'proper' graphics software there's some wrongness that I could be averting if I actually knew what I was doing.

So when, on 8 February 2013, I found myself in the mood for a quick doodle, Microsoft Paint seemed like the obvious choice for the job. I asked my friends on Facebook if they wanted me to draw them anything and, surprisingly, a lot of them did. Once I'd proven I could deliver it was clear people wanted to see what bizarre requests I was willing to waste my lunch breaks fulfilling and as a result I found myself putting the finishing touches on 'an anthropomorphised New York skyline battling a giant religiously fanatical prawn' whilst wondering exactly what the hell I was doing with both my lunch breaks and my life.

Soon after that someone suggested I share the project on image blogging site de facto, Tumblr. Before long it was clear something weird was happening. I was being sent literally hundreds of suggestions every day from people I didn't know, each more brilliant, surreal and downright funny than the last. For the first few weeks I did nothing but try in vain to keep up – reading as many suggestions as possible before work and then painting all evening, every evening before eventually skulking to bed with bloodshot eyes.

What started off as a hobby was turning into a bizarre, full-time occupation and it was becoming apparent that I couldn't keep juggling my new role as an 'internet thing' with a full-time, real-world job. Especially as, with my technique improving, each piece was taking around six hours to complete and often much longer (the picture of Stirling Moss playing chess with Lee 'Scratch' Perry inside Ken Dodd's mouth took three days of solid pixel wrangling). It didn't occur to me for a moment to simply stop so instead I took the plunge and quit my job, subsidising my time by selling Jim'll Paint It prints and T-shirts.

From those first explosive weeks on Tumblr a book had always been in the back of my mind and now, with the help of some very talented individuals, it's very much sitting up front. To see the culmination of the past fifteen months' work – a compendium of strangers' dreams translated as faithfully as possible into pixels and amassed in print for the very first time – has allowed me a fresh sense of perspective. What's been learned from this unique and serendipitous experiment? Is it art? Is it comedy? Is it any good? Regardless of what people think of these pictures, it should be clear that the entire project has been born from pure joy. A collaboration between myself and a hundred other humans with very strange dreams.

Jim, May 2014

ELECTRIC DREAMS

Ainsley Harriott, son of God

As requested by Stephen

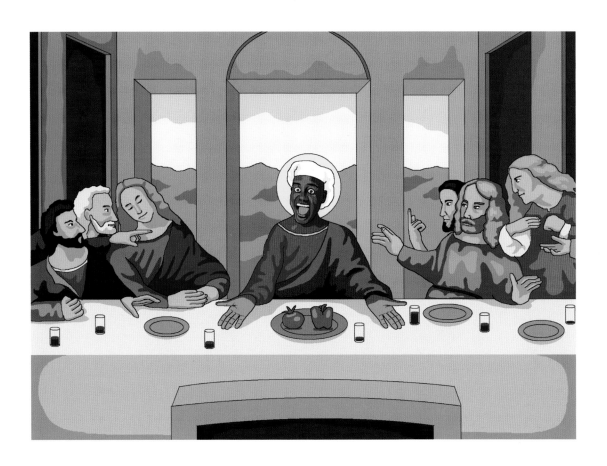

Dear Jim,

Please could you paint me Jarvis Cocker sideways on a London tube in a fireman's outfit playing the harpsichord.

Kind regards,

Frank

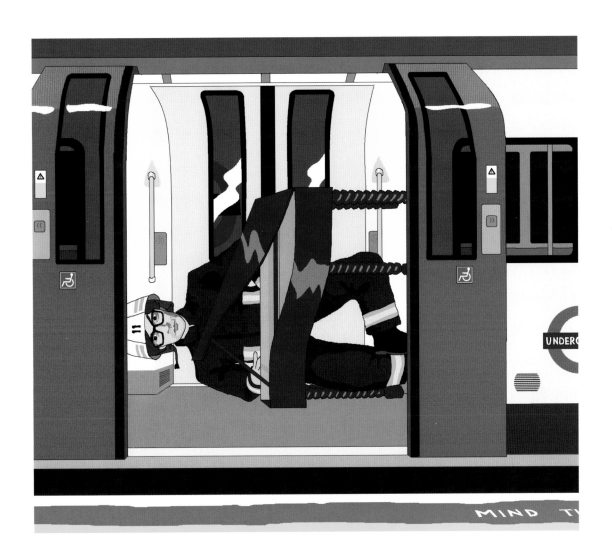

Bruce Forsyth in the woods, wearing a black cloak, crouched over a dead unicorn, with blood around his mouth

As requested by Joe

Dear Jim,

Please paint me an anthropomorphised New York skyline battling a giant religiously fanatical prawn. Meanwhile the Diamond Falcon contemplates.

All the best,

Carl

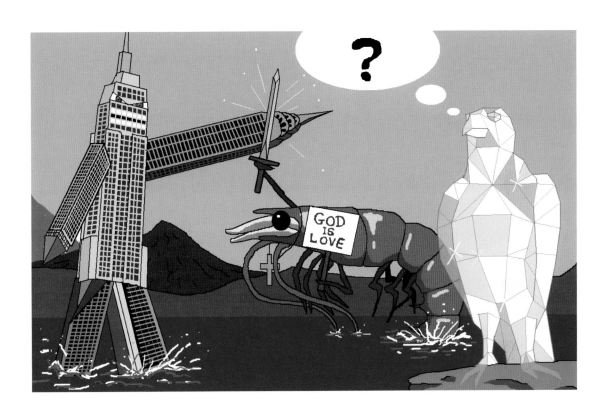

Dear Jim,

Please paint me an episode of popular Saturday dating show Take Me Out in which the young man coming down the love lift is the Norris-Thing from The Thing. It is attempting to absorb and replicate the desperate screaming female contestants and to the side Paddy McGuinness vomits on his chest in fear. This horror could have been averted if not for the fact that Kurt Russell, sitting in the audience armed with flamethrower and a mighty beard, has spotted himself on camera and is waving to family.

Thanks,

Greig

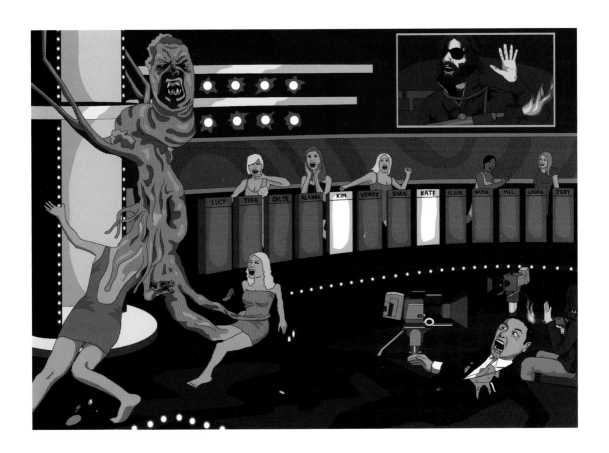

Dear Jim,

Please paint me Nigella Lawson eating a plate of Pentium 4 Processors with her metal teeth. In the background, we can see a mecha-war going on out of her window, on the streets of Bristol. Oh, and she's drinking Duracell branded battery acid.

Thanks,

otakukuma

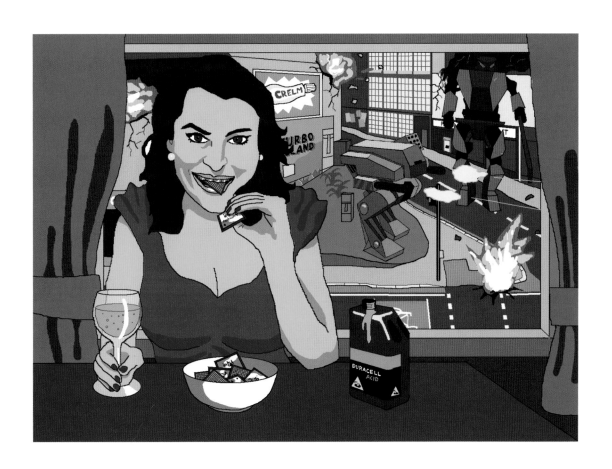

Dear Jim,

Please paint me the moment David Blunkett's guide dog is exposed as the infamous street artist Banksy . . . Blunkett is completely oblivious − naturally thinking the gentle hiss coming from his dog near a wall was a call of nature.

Kind regards,

Vin

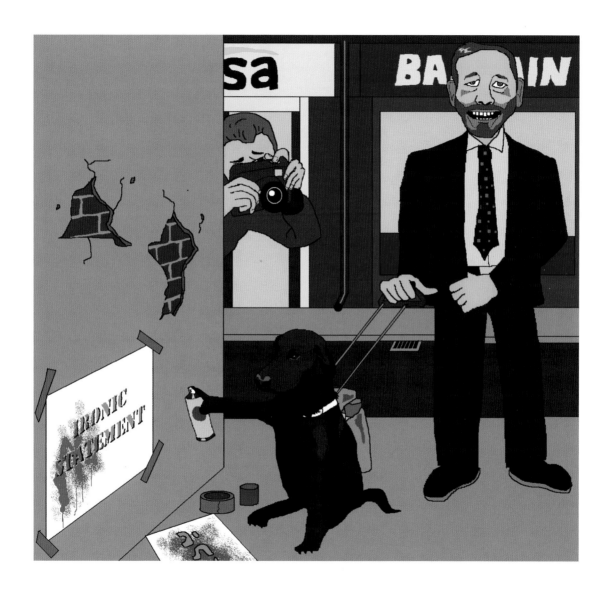

Dear Jim,

Please paint me Charlie Sheen winning.

Cheers,

Matt

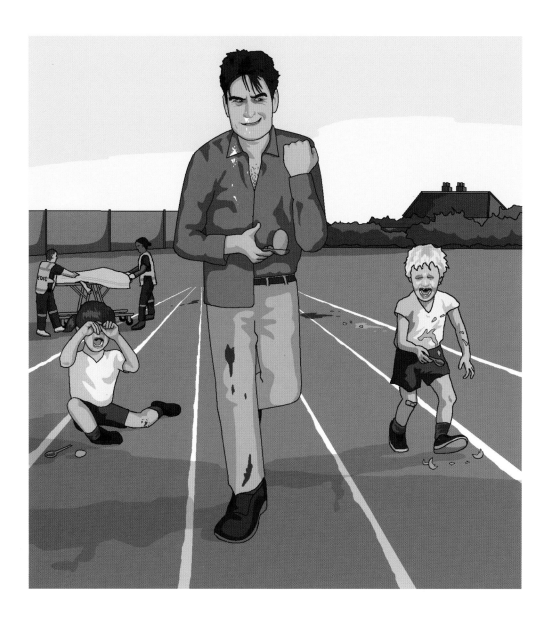

Dear Jim,

Please will you paint me a picture of Jonah Lomu in his All Blacks kit punching will.i.am in the face from atop his magical, sparkly rhino which he likes to ride about rural Kent. The punch sends Mr Am flying over a farmyard barn full of hay. The attack is witnessed by Terry Nutkins while he enjoys a Malteser sandwich dressed as the green Power Ranger without his helmet.

Thanks,

Paul

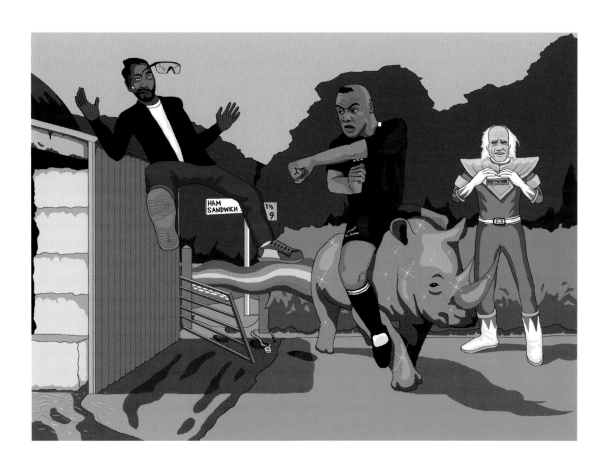

Dear Jim,

Please paint me Steven Seagal, Jeremy Kyle and Slipknot on an 18–30 holiday in Weston-Super-Mare. Kyle is pissed at Slipknot for using all the semi-skimmed milk but Seagal steps in and offers his almond milk as an alternative. There happens to be a Lilliput Lane Pottery Collectors convention taking place on the beach as well.

Cheers,

Stephen

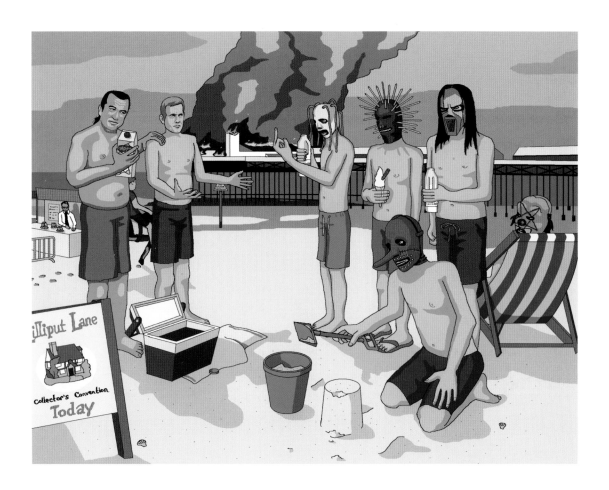

Dear Jim,

Please paint me Judge Dredd's adventures in Oz, complete with Tin Man Ricky Gervais, Scarecrow Hugh Laurie and an actual lion, who it has been impossible to inform of the script and is thus savaging a munchkin.

Cheers,

Robert

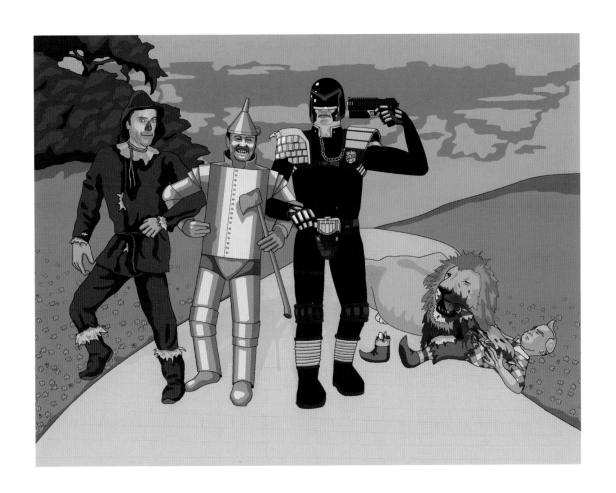

Jeremy Beadlejuice

As requested by Andrew

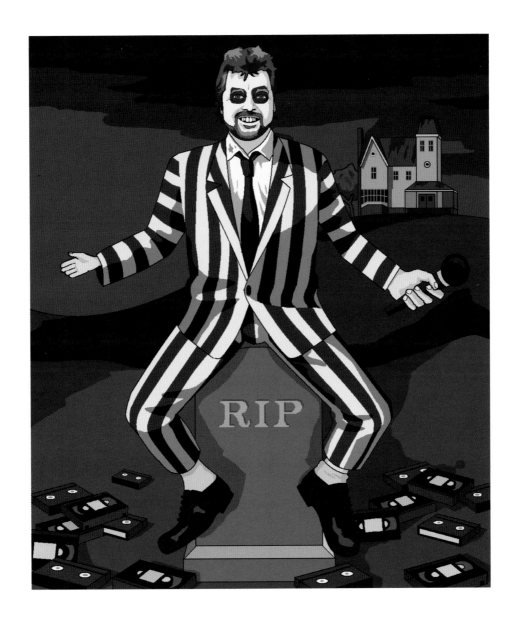

Dear Jim,

Please paint me 'Bach to the Future'.

Sincerely,

Simon

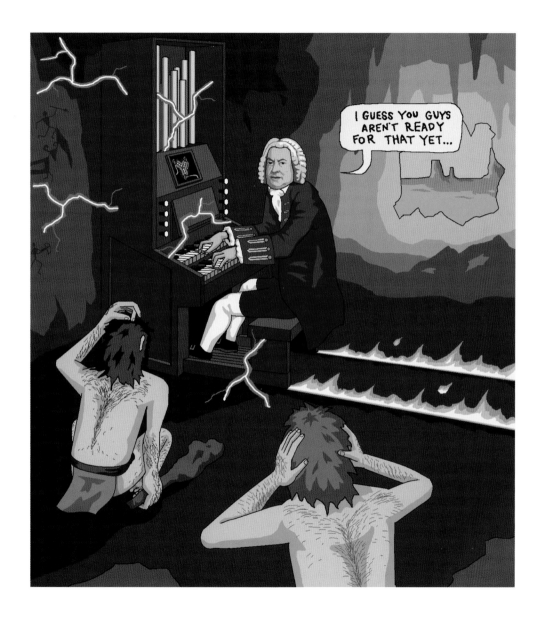

Dear Jim,

Please paint me Bono making out with a human-sized bishop chess piece. Bono looks genuinely angry, and the bishop is wearing a shirt that displays its hatred for human beings. This takes place in a serious-looking office filled with serious-looking workers with motivational signs around the room encouraging all kinds of seriousness. On the right-hand side, Angus Deayton has grown a set of wings and is confused as to why he has them.

Thanks,

Chris

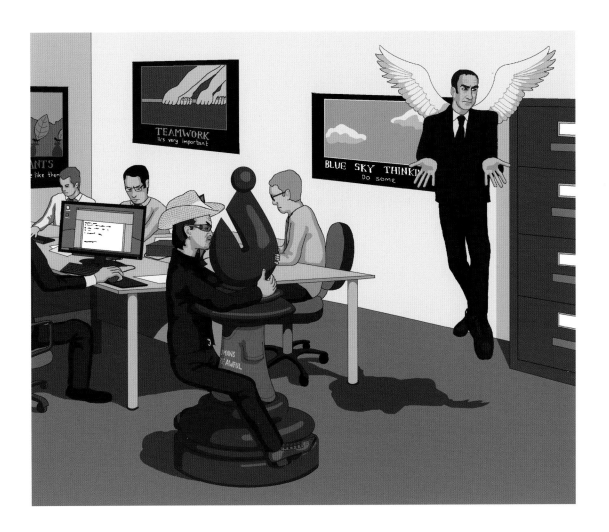

Dear Jim,

Please paint me Antony Worrall Thompson making an absolutely pathetic attempt at shoplifting in Pets at Home. He's trying to conceal a fishtank under his jumper, a pair of love birds in his bumbag and there are gerbils spilling out of his pockets. His poorly thought-through disguise consists only of a beard fashioned from orange-coloured hamster bedding. His expression should reflect a sense of exasperation at his own stupidity as he realises that he already had a real beard of the exact same colour to begin with.

Thanks,

Dave

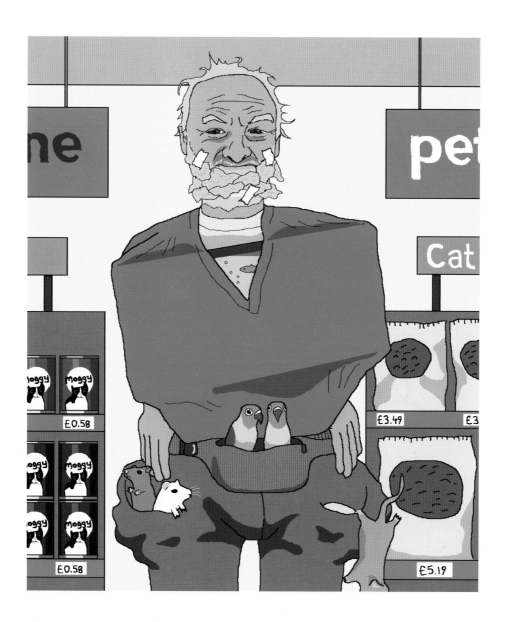

Dear Jim,

Please paint me Pinhead from Hellraiser *getting flustered while on* Celebrity Masterchef.

Thanks,

BeeLog

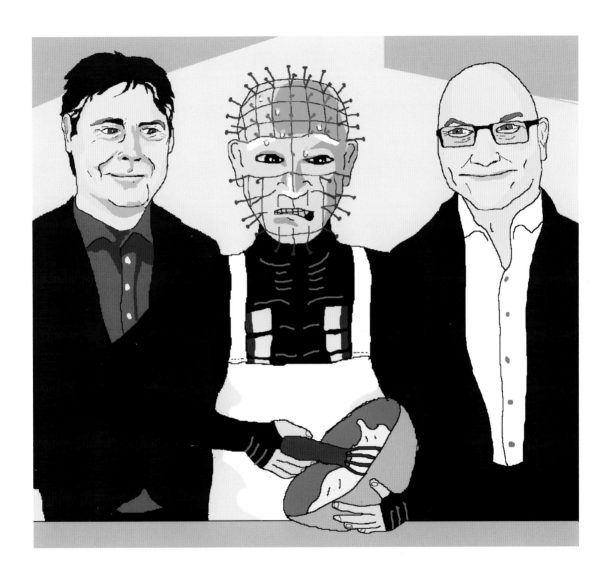

Noel's Post-Apocalyptic House Party

As requested by Chris

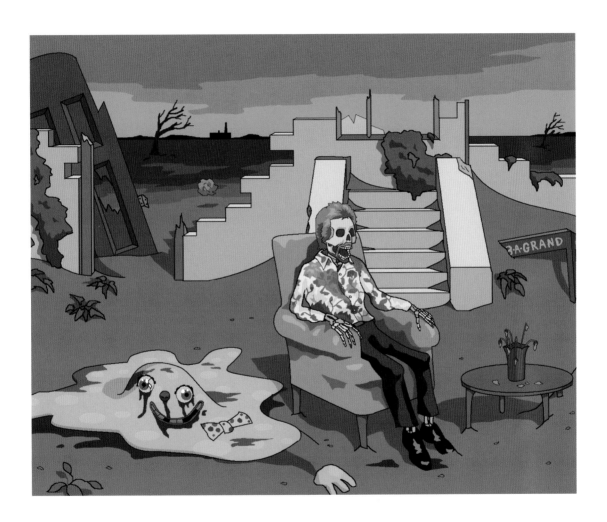

Dear Jim,

Please paint for me Bill Murray (*wearing his umbrella hat from* Space Jam) *simultaneously bathing a penguin in a bubble bath (with the pirate version of Matey bubble bath) whilst playing a game of curling.* Monty Python and the Holy Grail*'s* Black Knight *is one 'sweeper', the other is an overly enthusiastic David Schwimmer wearing a 'Geology Rocks' T-shirt. This is all taking place in a room reminiscent of the set for* Blind Date *and Charlie Sheen looks on through a window juggling a can of Diet Coke, a grenade and a pack of Mentos.*

Thanks,

Patrick

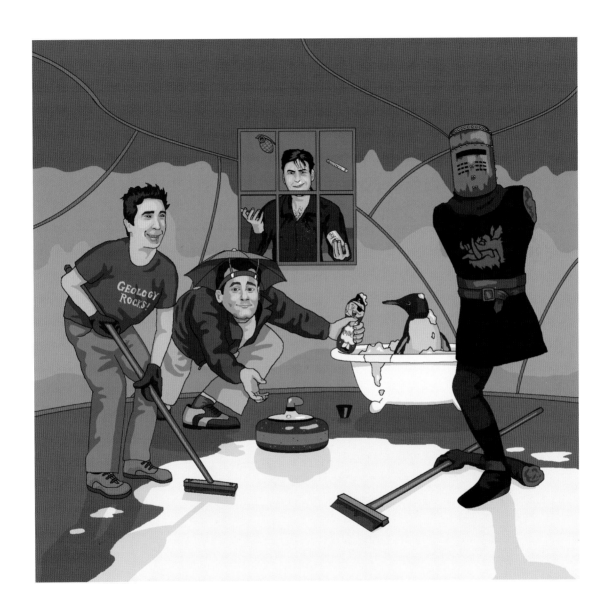

Dear Jim,

Please can you paint a mulleted Pat Sharp chasing Melanie and Martina through the Fun House with an axe, in the style of Jack Nicholson / The Shining.

Thanks,

Sam

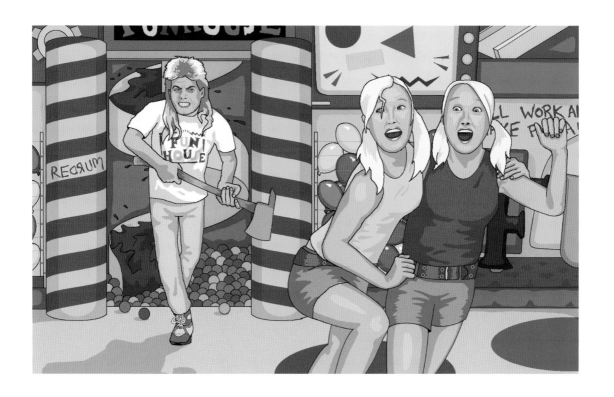

Dear Jim,

Please paint me Wolf from Gladiators *exiting one of the telepods from the 1986 movie* The Fly. *He has accidentally entered the telepod holding his old school Nokia 3210 and has emerged a half man/half mobile phone mutant.*

Thanks,

Barri

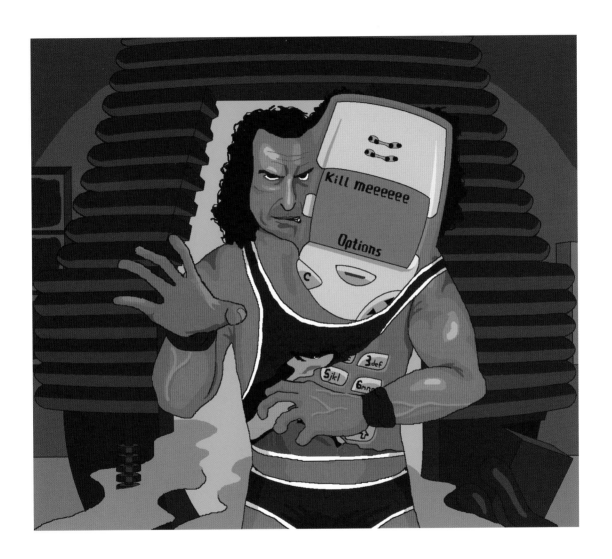

Dog the Bounty Hunter having a relaxing bath

As requested by Lennon

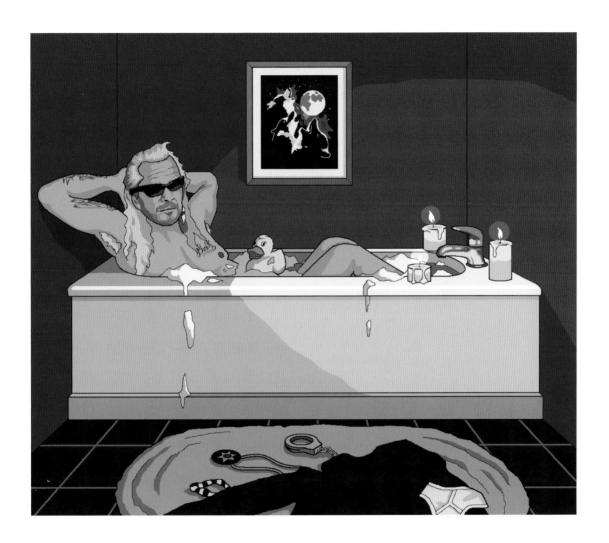

Dear Jim,

Please paint me the famous Jules and Vincent gun pose from Pulp Fiction *. . . only replace Samuel L. Jackson and John Travolta with Harold Bishop and Phil Mitchell.*

Cheers,

Ryan

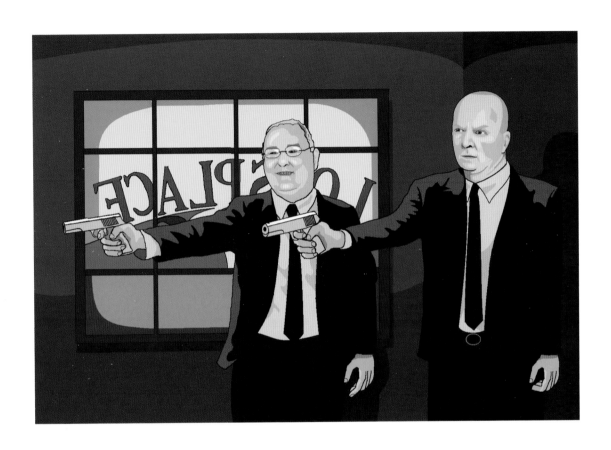

Vladimir Putin as every member of the Village People

As requested by Matty Knight

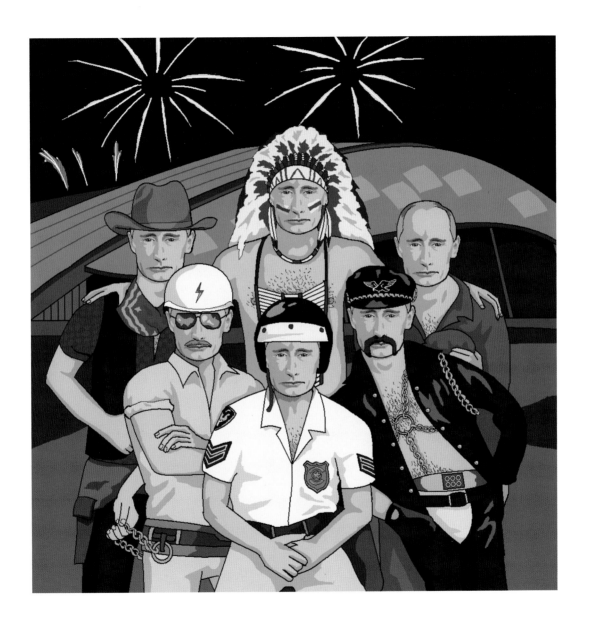

Madonna drying out cigarette ends under a hand drier in the ladies toilets in Wetherspoons

As requested by Liam

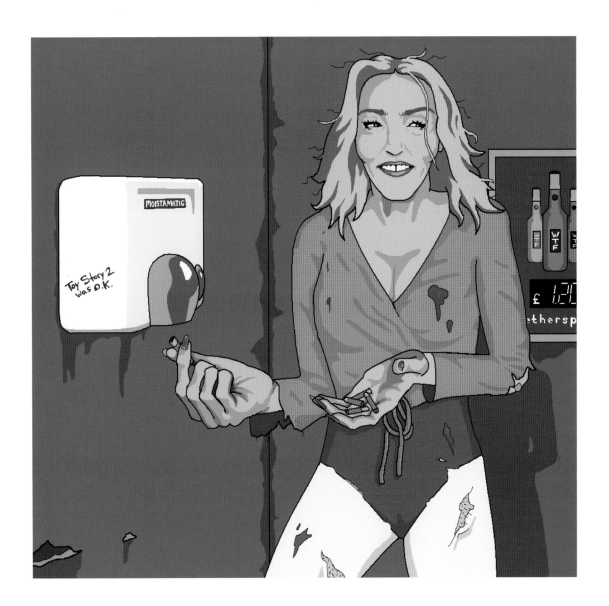

Dear Jim,

Please paint me a bat in a leotard being distracted by a violin sticking out of a rainbow-coloured bottle bank next to a three-legged Toffee Crisp holding a mushroom and half a wasp. In the background is a turtle having a tennis lesson, and an upside down Taj Mahal covered in ears.

Thanks,

Darren

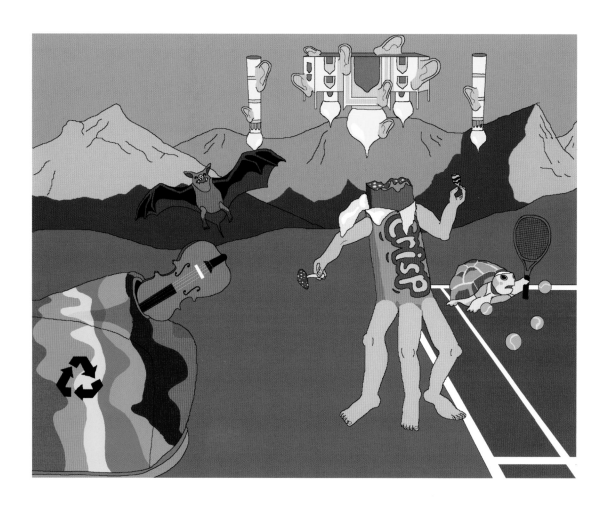

Dear Jim,

Please paint me Jimi Hendrix explaining to an owl on his shoulder what a stick of chalk is, near a forest.

Thanks,

onemariannestephen

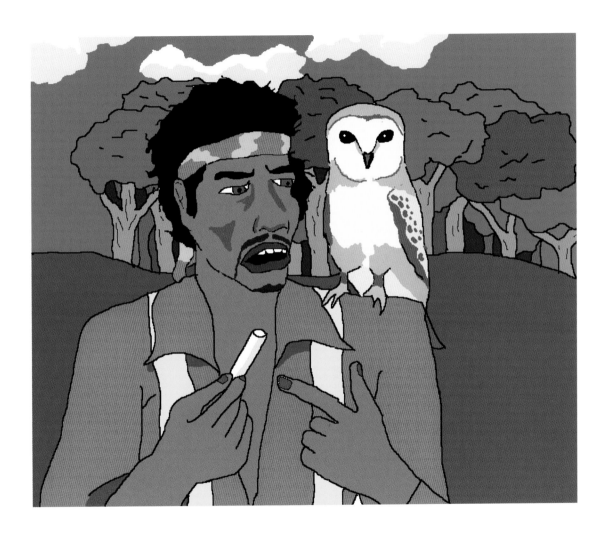

Dear Jim,

Please may you paint an alien civilisation consisting of Nicolas Cage lookalikes bowed down praying to a statue of Adrian Chiles.

Cheers,

Jordan

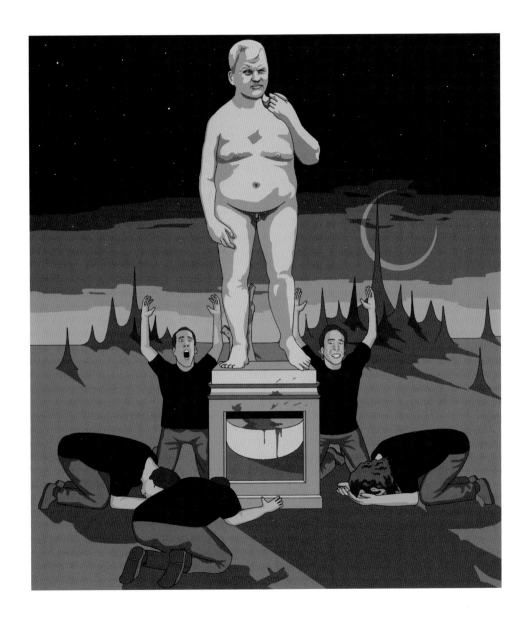

Jim,

Would you kindly draw me Cher riding on the back of the Duke of Wellington statue through Glasgow.

I'd greatly appreciate it. Thanks.

Nicki

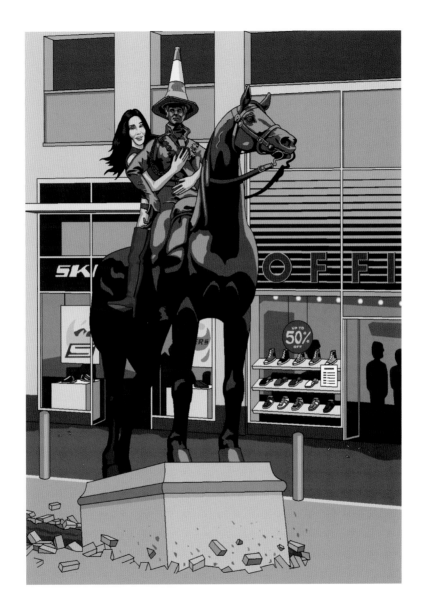

Coronation Street Fighter II

As requested by Rib

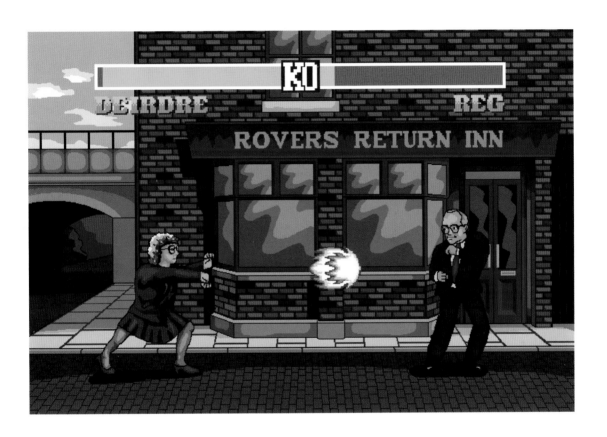

Dear Jim,

Please paint me the Stay Puft Marshmallow Man losing a game of Mousetrap with Hugh Fearnley-Whittingstall (who happens to be on fire) while Face from The A-Team arrives on a pigeon dressed in leopard-print Y-fronts and wedding veil, all this is taking place on the moon.

Thanks,

Phil

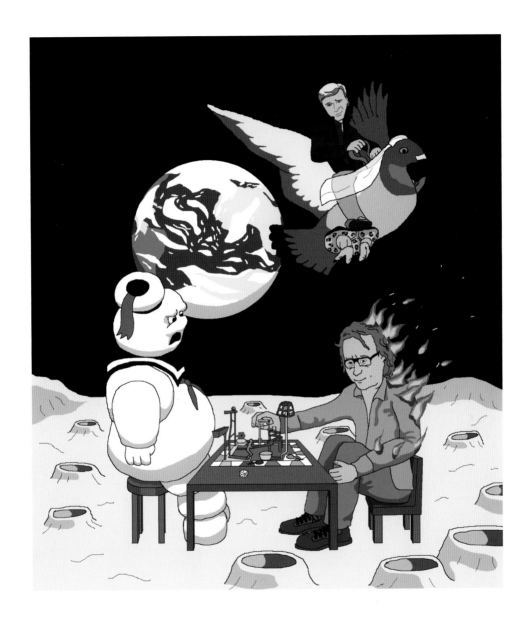

Tinned Lenin

As requested by Ben

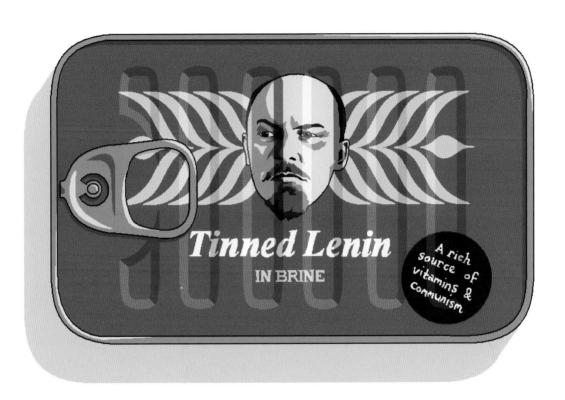

Dear Jim,

Please can you paint Frankie Boyle teaching children how to swear.

Thanks,

David

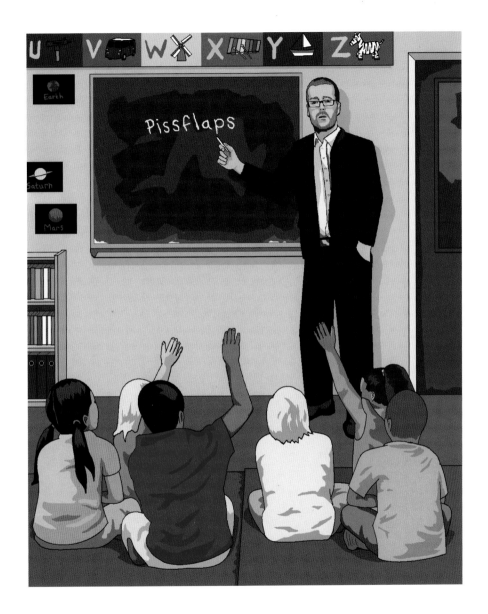

65

Dear Jim,

Please paint me Morrissey eating a horse.

Regards,

Oliver

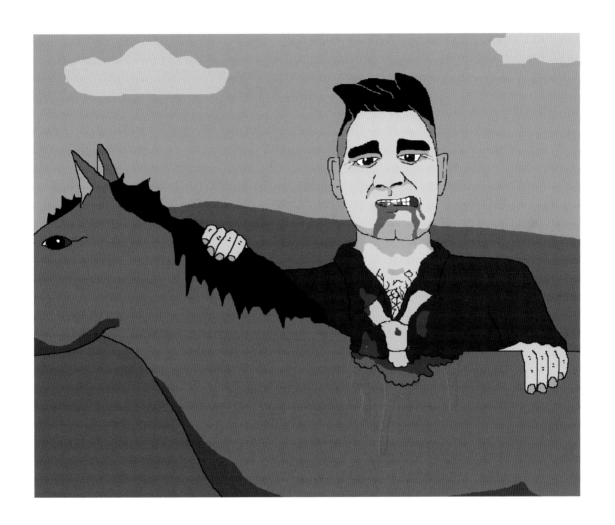

Dear Jim,

Please paint me a guinea-pig version of Burt Reynolds on a sunlounger being served drinks by Hulk Hogan wearing only the top half of a tuxedo.

Thanks,

littlecthulhu

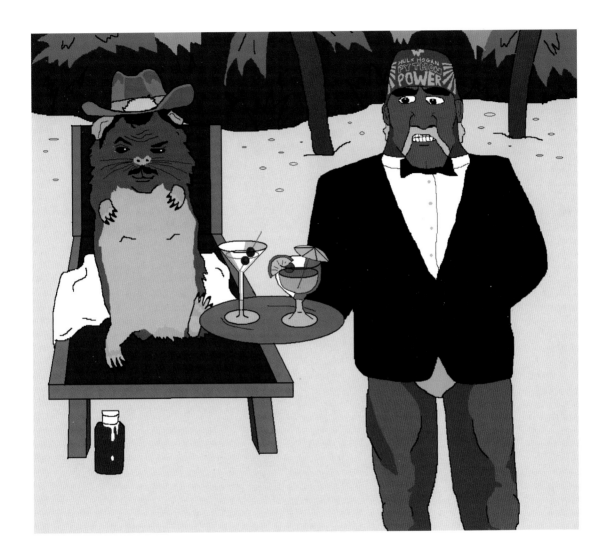

Dear Jim,

Please paint me Ross Kemp on toast.

Cheers,

Toby

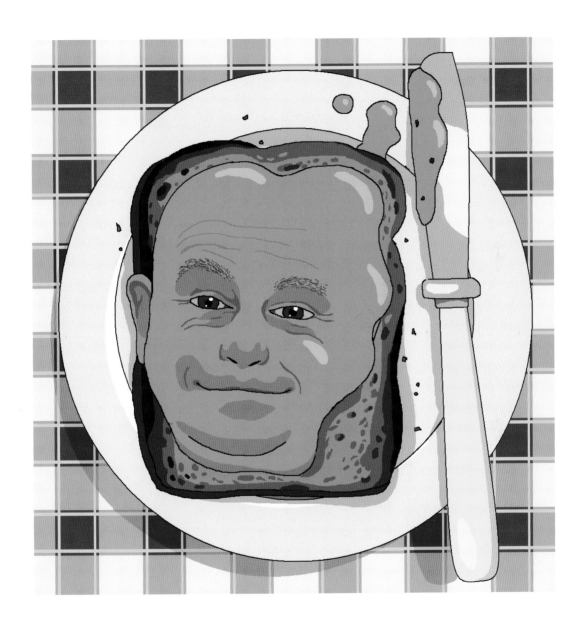

Dear Jim,

Please can you paint Daft Punk Morris dancing on the surface of Mars wearing only their helmets and official Morris dancing tassels and braces. Adam Ant is shredding on the electric guitar to accompany the dance. The sun has gone supernova and Earth is exploding in the distance.

Godspeed,

David

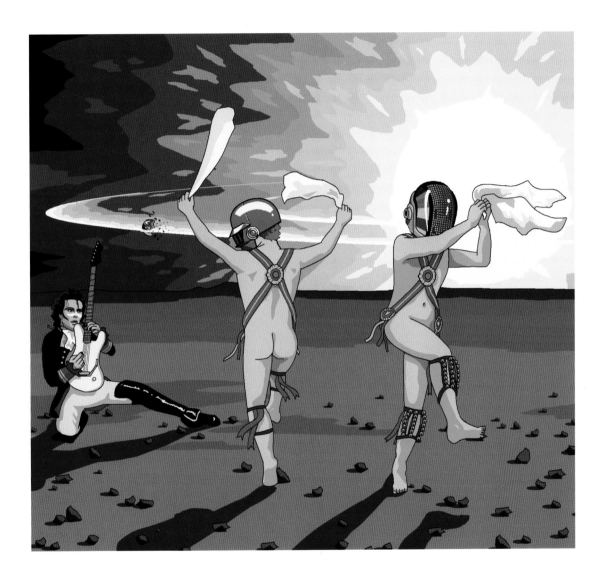

Alexander Armstrong taking an axe to Richard Osman's laptop on Pointless *whilst wearing a tutu, jackboots and a WWI German helmet. Osman looks on while stroking a white cat.*

As requested by Keith

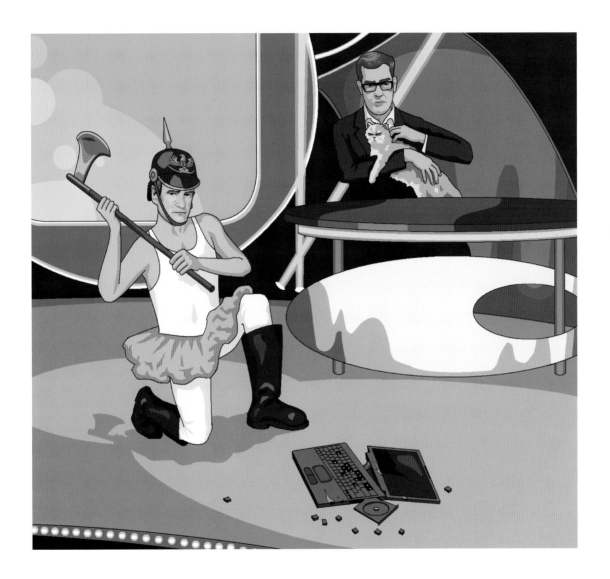

Trevor McDonald as a sunflower

As requested by Joey

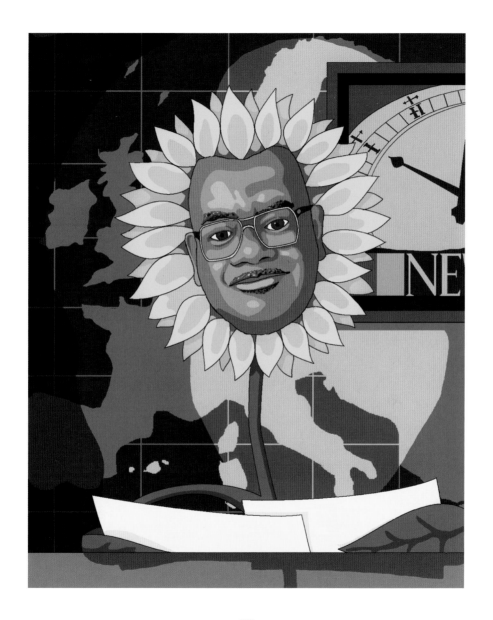

Dear Jim,

Can you please paint me Davina McCall with dreadlocks, cooking a full English breakfast on the beach, and all of the seagulls at the beach are in karate kit and/or Nazi uniforms and are attacking her and her breakfast is on fire and there's a dog poo on the beach (it's not a very nice beach) and she's smiling a lot staring right at you smiling in a really creepy way with big gold hoop earrings in and can Davina please be dressed in pyjamas and have spiders coming out of her eyes a little bit.

This painting would make me very happy, thank you.

Gemma

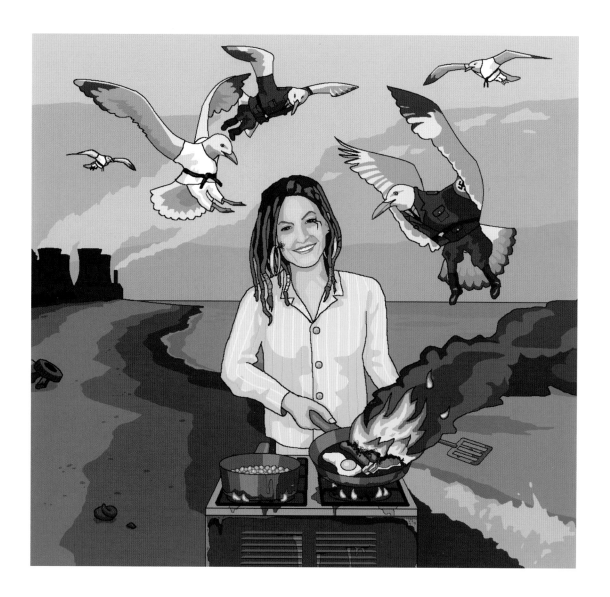

Your own birth

As requested by Adam Clery

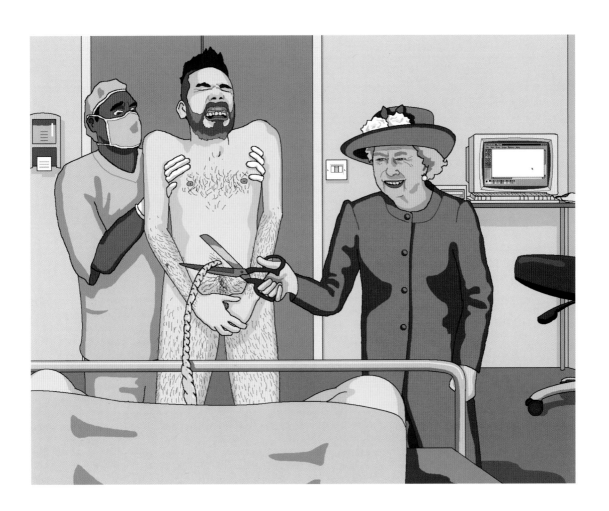

Dear Jim,

Please paint me a picture of Brian Blessed riding a Henry hoover alongside D'n'B DJ Goldie on a Dyson. They are racing on the Mario Kart level Rainbow Road and are both drunk on White Ace cider.

Thanks,

Tommy

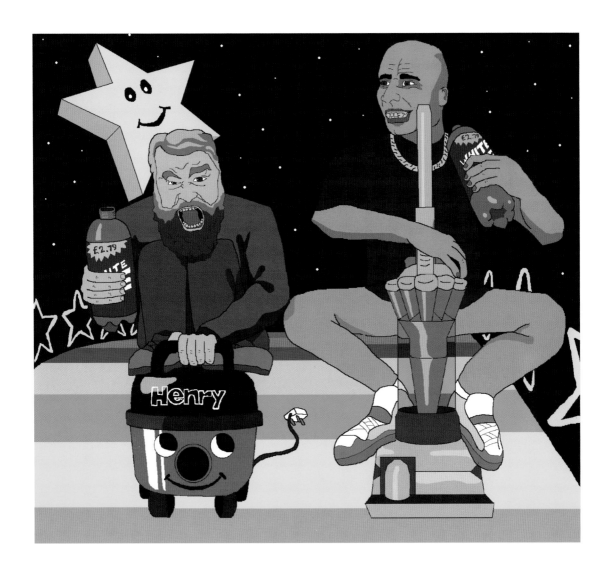

Hi Jim,

I'm Goldie's son Danny and for the last month or so every fucker in my town has come up to me asking, 'Have you seen that picture of your Dad riding a hoover?' So can you please draw a picture of me looking disappointingly at the picture you drew of my dad whilst everyone around me points and laughs? Some of the people in the crowd are that annoying fat guy from the old wonga.com advert, Ian Beale, Simon Cowell, Ant (from Ant and Dec) and Brian Harvey from East 17.

Thanks,

Danny

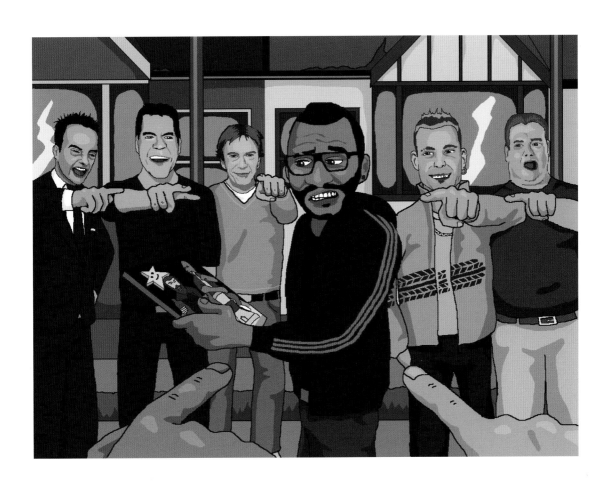

The pope as a space marine

As requested by Sam

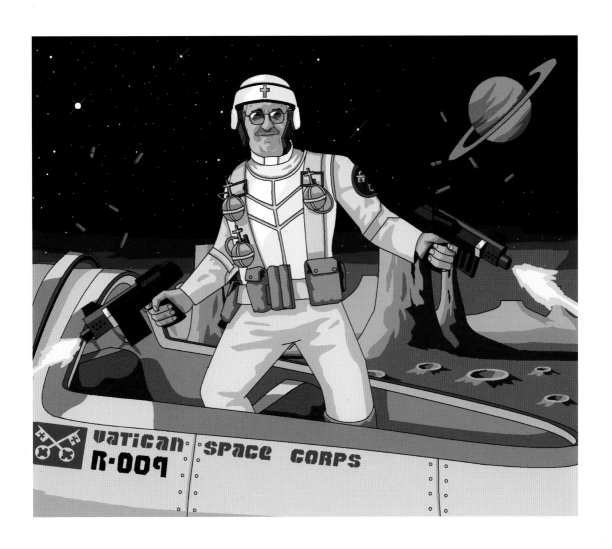

Dear Jim,

Please paint me the T-Rex attack scene from Jurassic Park, *but the T-Rex is the band T-Rex.*

Thanks,

Matthew

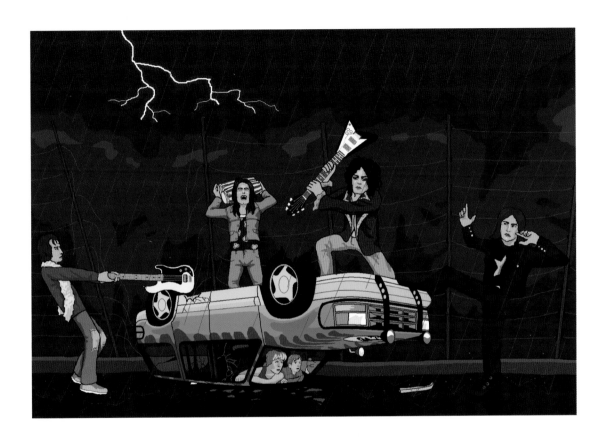

Hi Jim,

Please paint for me the moment Richard from Keeping Up Appearances *finally and deservedly snaps.*

As requested by Richard

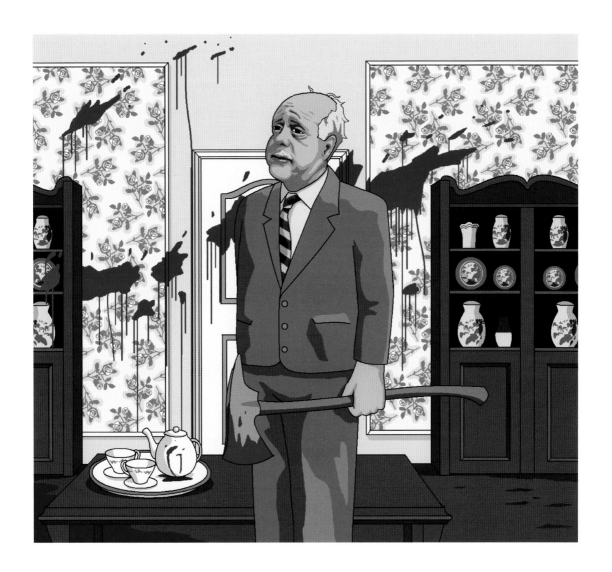

System of a Downton Abbey

As requested by Paul

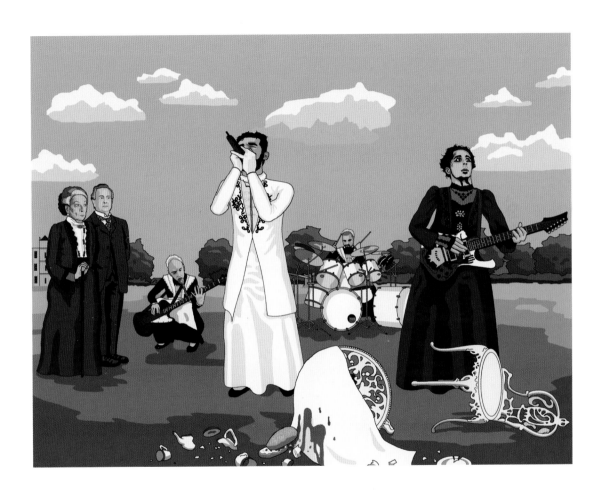

Dear Jim,

Please paint me Jeremy Kyle who has somehow been filled with bees. He drives around in Ecto-1 from Ghostbusters *while his best friend Danny DeVito clings to the bonnet for dear life. For some reason DeVito is wearing an ill-fitting McDonald's uniform that is way too small for him. I forgot to mention that they just flew from the mouth of Stephen Fry, smashing every tooth on the way out. Stephen looks very angry.*

Thanks,

Dean

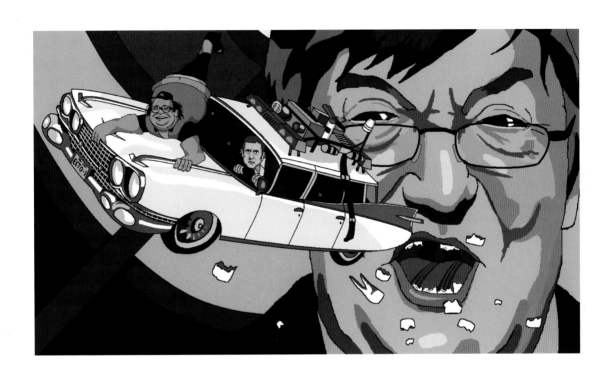

Dear Jim,

Please paint me Loyd Grossman on holiday in a filthy Spanish villa, where he is apoplectic after being served a dinner of tinned ravioli and a glass of flat fizzy pop.

Sincerely,

Chris

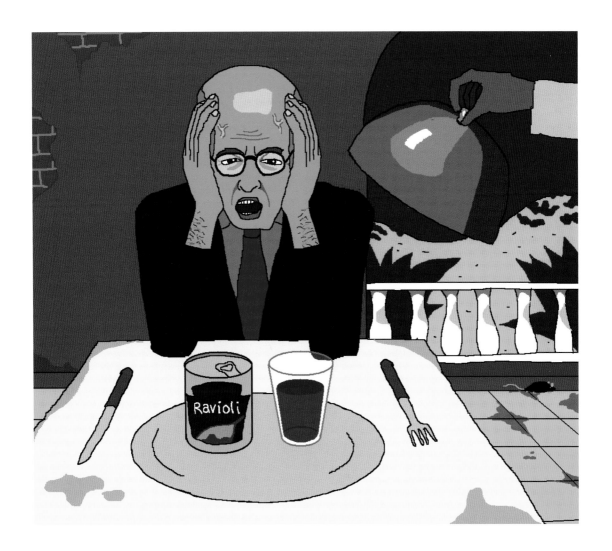

Dear Jim,

Please paint me American rock-pop band Hanson playing live in a small bathroom. There are dead pigeons everywhere. A naked Mick Hucknall is curled up in a corner eating crayons.

Thanks,

Natalie

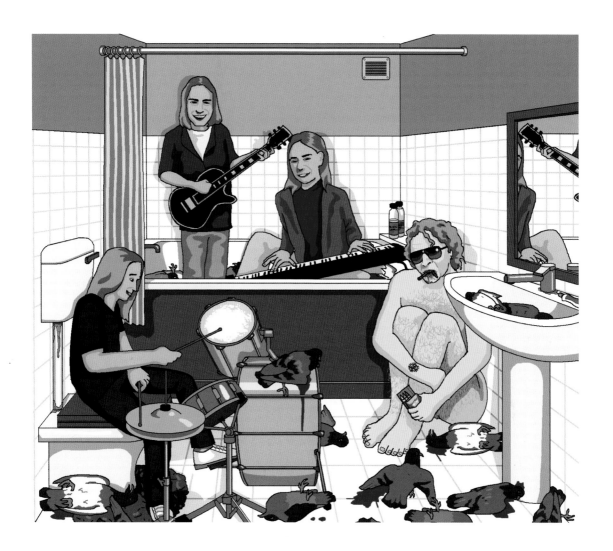

Dear Jim,

Please can you paint Dot Cotton having a bad trip.

Cheers bud,

Toby

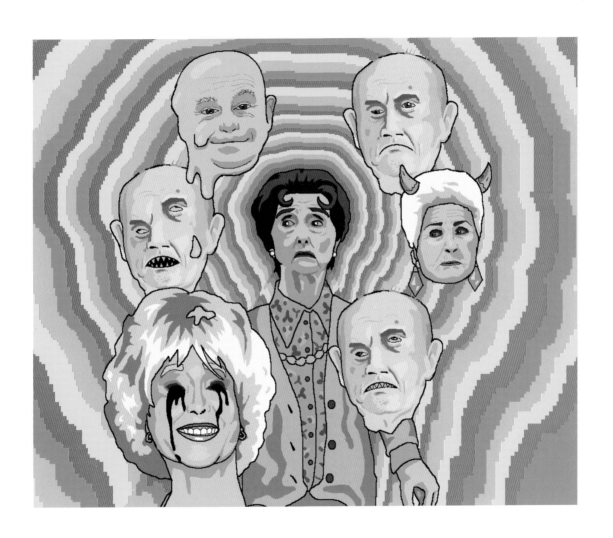

Dear Jim,

Please paint me Paul Daniels, who is dressed in Debbie McGee's stage clothing, morosely barbecuing a large solitary sausage and two brown balls whilst llamas in mariachi costumes serenade him. This is taking place onboard the USS Voyager, *the replicator of which is malfunctioning and spewing out an unreasonable quantity of Flumps. Wizbit should also be present, attempting to hang himself but failing on account of his triangular shape. The sausage should bear a resemblance to David Dickinson.*

Thanks,

Alan

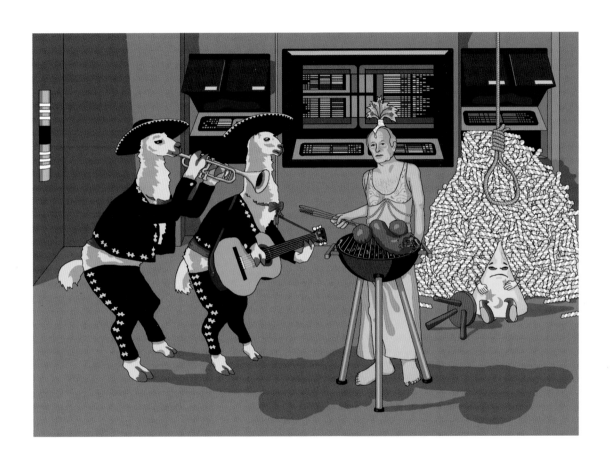

Jeremy Clarkson can't eat cereal

As requested by Jamie

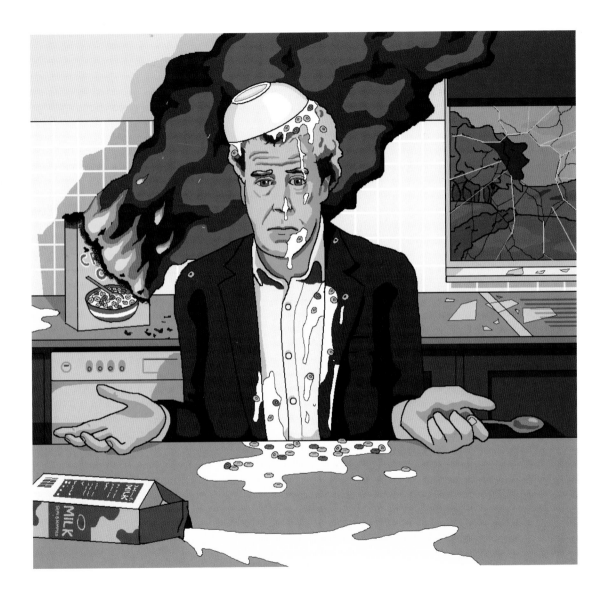

105

Dear Jim,

I work in nightclub bookings and have recently received separate emails asking if I'd like to book Coolio, David Hasselhoff and 'the smallest DJ in the world'. I'm debating putting them all on together on the same night so could you paint it for me so I can see if it's a good idea or not?

Thanks,

Jim

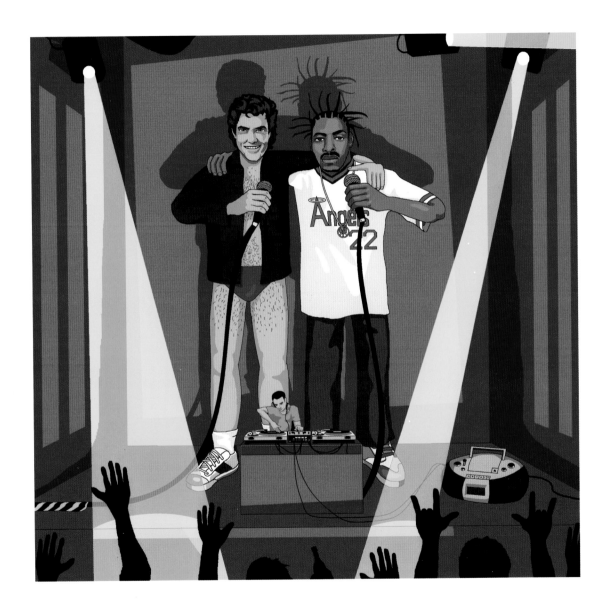

Prince Philip discovers the internet

As requested by Chris

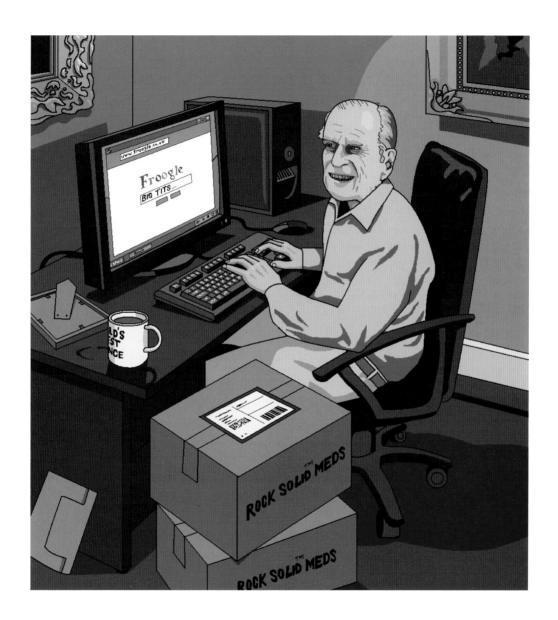

Dear Jim,

Please paint me Kriss Akabusi dressed as Santa with Kriss Akabusi sitting on his knee receiving a signed picture of Kriss Akabusi as a present.

Cheers,

Andrew

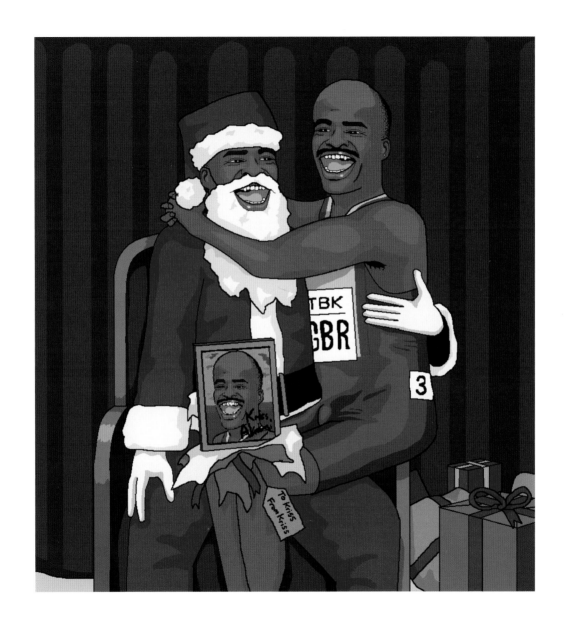

Dear Jim,

Please paint me a long queue of Leonard Nimoys standing in line to inflate Russell Brand's head. There is a foot pump in front of Brand, and the nozzle is in his mouth; he looks frightened but determined. The Nimoys are paying 50p a pump, and judging by the size of Brand's distended and perilously stretched head, and the pile of coins in the bathtub next to him (in which Ann Widdecombe is reclining wearing Michael Jackson's 'Thriller' suit) they've been at it quite a while. This is all happening in the foyer of the Westfield shopping centre; a protective tarpaulin has been laid on the ground, and painted on the bathtub are the words 'For Comic Relief'.

Thanks,

Colin

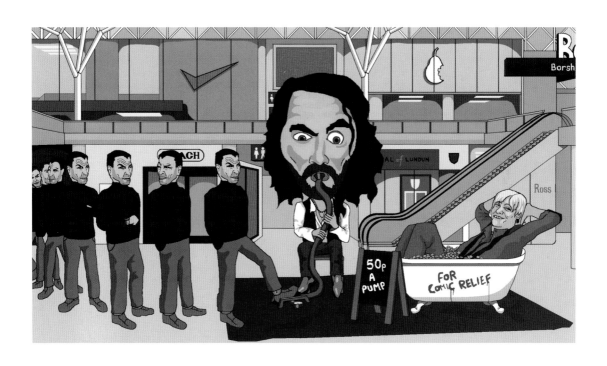

Dear Jim,

Please can you paint for me the beautiful moment when Voldemort finally finds a Coke bottle with his name on it.

Cheers,

Lee

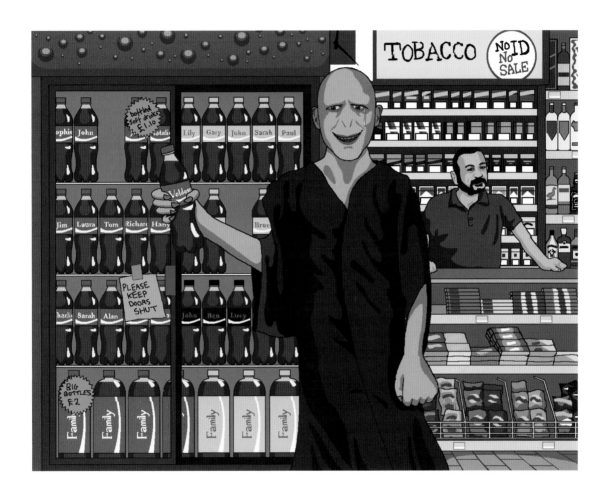

A shoal of Michael Fish

As requested by Dave

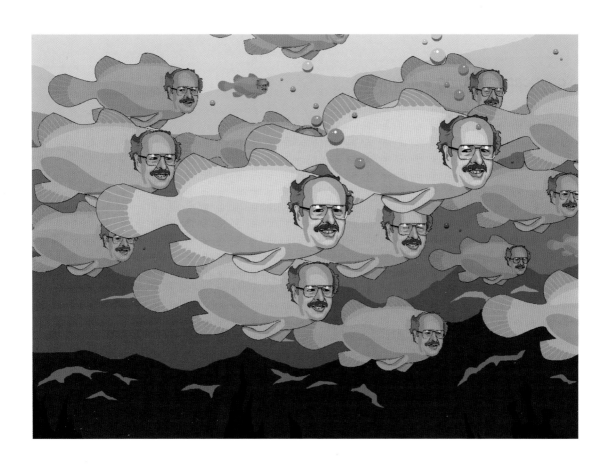

Some cats rescuing a fireman

As requested by Ben

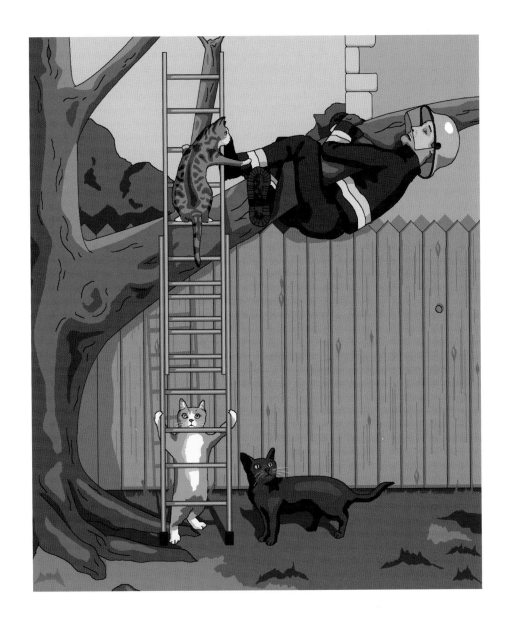

Camel astronaut wrestles Sheffield Wednesday

As requested by Louise

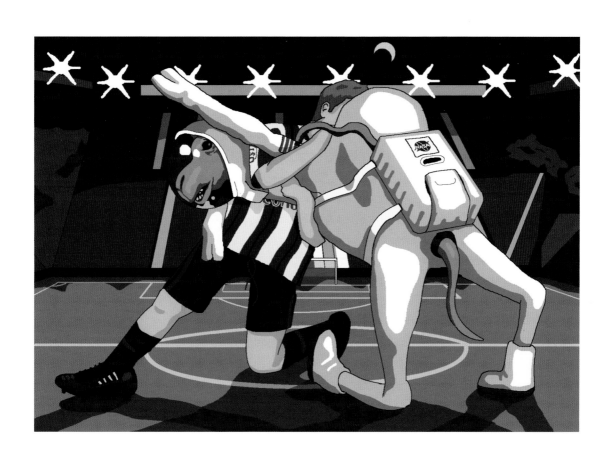

Dear Jim,

Please paint me Bill Murray catching a bank robber using only his charm while members of the Tokyo police force shield themselves behind him.

Thanks,

dbaw

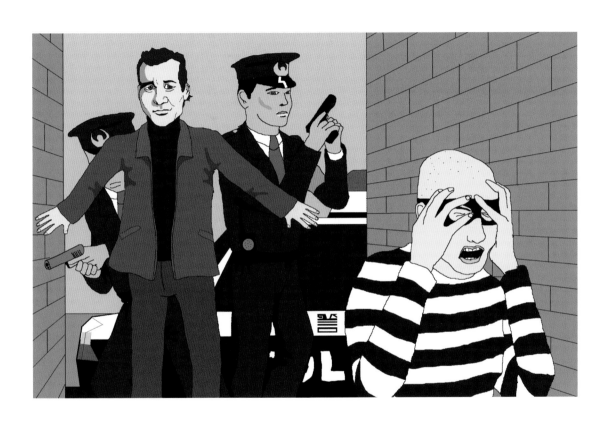

Tim Henman's Lovecraftian bobsled nightmare

As requested by Graham

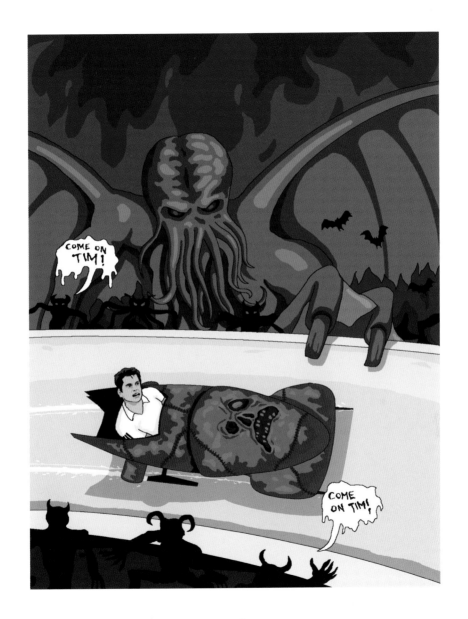

I've got limbs, they're multiplying

As uttered by Touretteshero

Last year Jessica Thom aka Touretteshero got in touch and asked if I would consider drawing one of her many abstract vocal tics which she has been recording for the past 3 years.

For more information about Touretteshero including the full list of almost 5,500 tics and other artwork inspired by them visit www.touretteshero.com

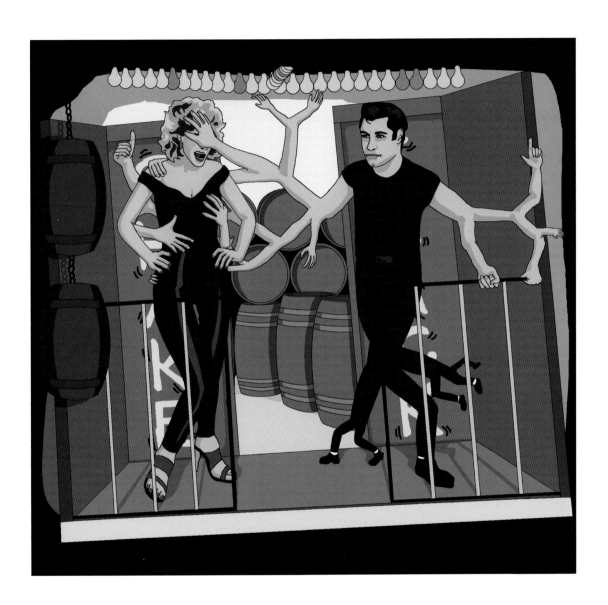

Mary and Joseph being turned away from a Premier Inn by Lenny Henry

As requested by Jon

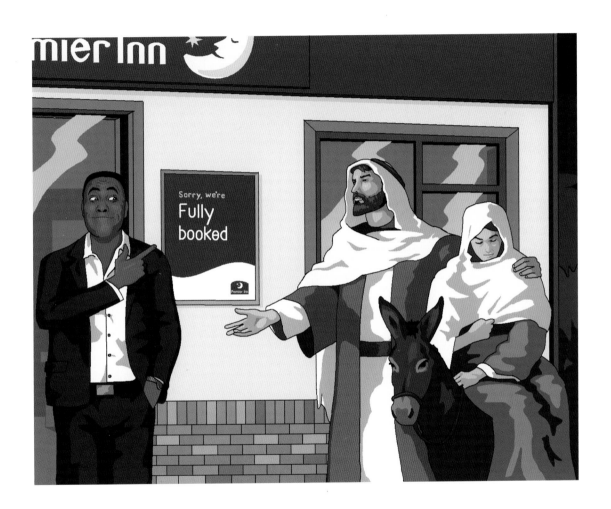

Dear Jim,

Please paint me John Lennon riding a penny-farthing, chased by a sausage dog. Where? Inside a Rubik's cube.

Thanks,

Liam

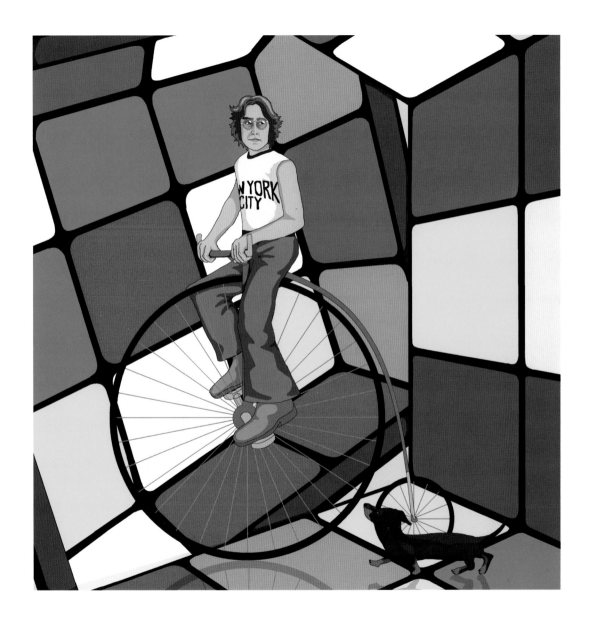

Dear Jim,

As a mark of respect in honour of a true comedy great, how about painting us all a lovely picture of a ghostly and jovial Harold Ramis being pursued by the remaining three Ghostbusters?

Matty, age 25 and 3/4

[I thought I'd throw in Punxsutawney Phil, some Twinkies and the skyline of his beloved Chicago for good measure.]

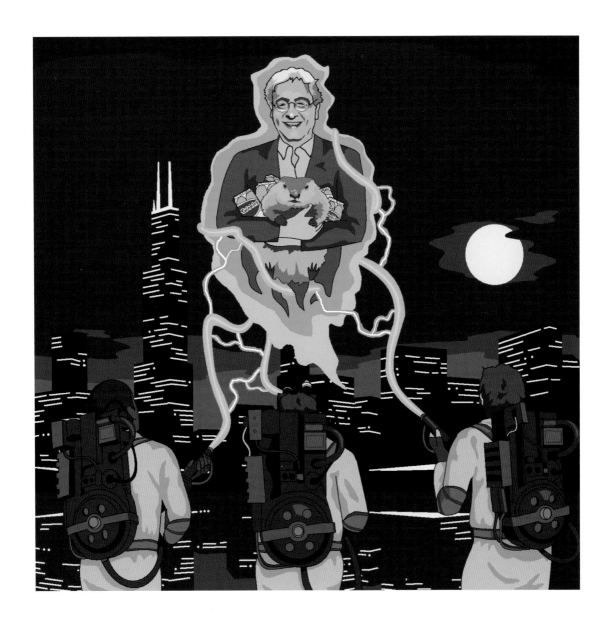

Dear Jim,

Please paint me Timothy Dalton having an intense arm-wrestling match at Stonehenge with Oprah Winfrey as William Shatner force-feeds her Spandau Ballet cassette tapes. Also Tupac Shakur is fly-tipping his knackered Hotpoint washing machine from his rusted-out blue Ford Transit.

Thanks,

Chris

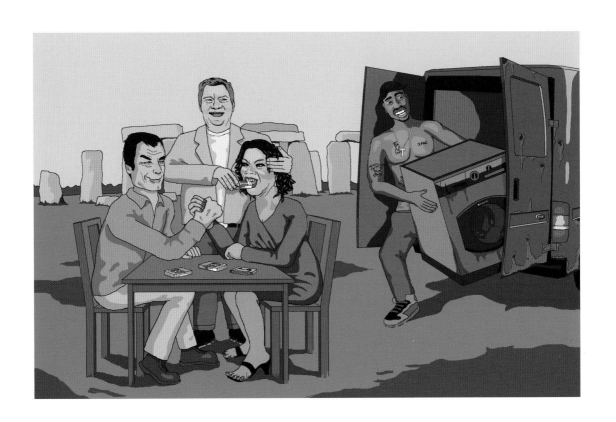

David Mitchell's garden-centre rampage

As requested by Dan

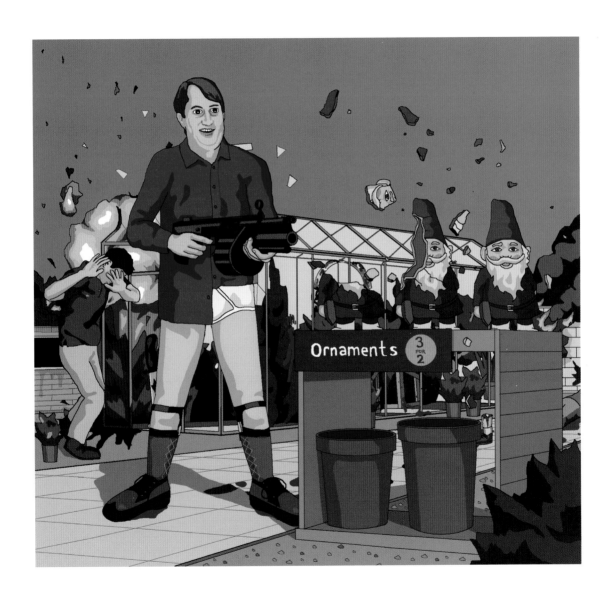

Dear Jim,

Please paint me your interpretation of a fight between a 'Daddy Long Legs' and a 'Daddy Strong Legs'. The latter is an insect with muscular human-like limbs who wears sunglasses and doesn't take shit from nobody. The former is an insect with dads for legs.

Cheers,

Tom

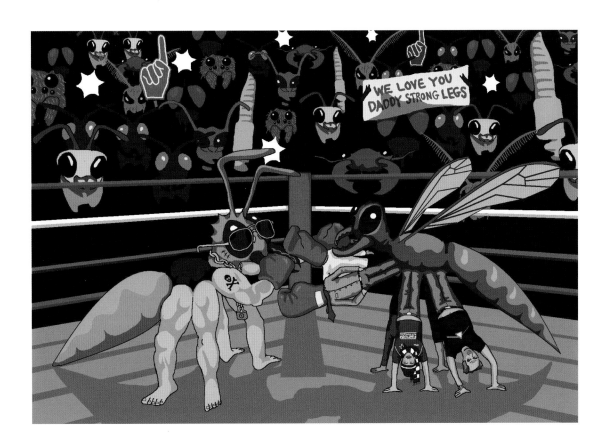

Dear Jim,

Please paint me the exorcism of twelve-year-old girl Regan MacNeil by the priests Father Ted Crilly and Father Dougal McGuire. Imagine everything that could go wrong has gone wrong.

Cheers,

Leo

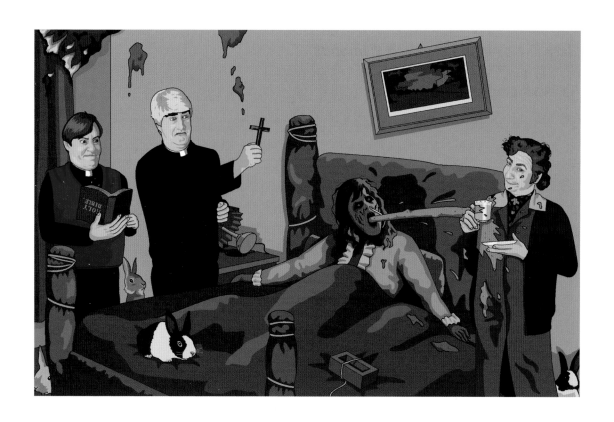

Gary Busey in the sky with diamonds

As requested by Drew

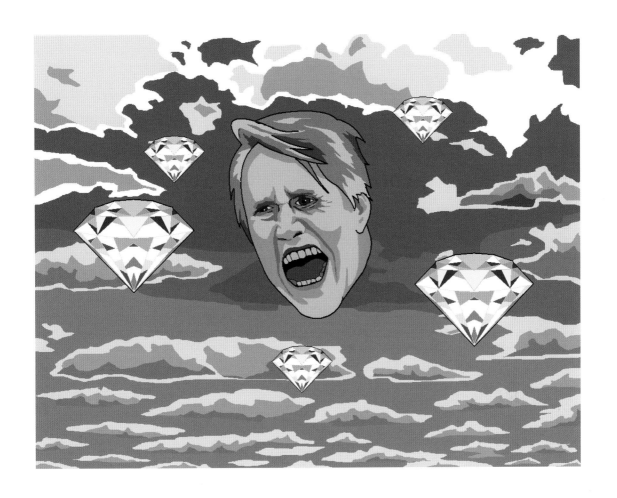

Dear Jim,

Please could you paint for me a young Stirling Moss playing chess against Lee 'Scratch' Perry on a oval chess board. Stirling has a side plate next to him with crumpets on it, Lee Perry has a glass of milk and a tiny statue of Damo Suzuki wrapped in a Brazilian flag, with a tub of Vicks VapoRub in the palm of its hand. The table on which the chessboard is placed is wooden and its legs are carved effigies of Nicholas Lyndhurst. On the floor in front of them is Danny Baker baptising East 17 in a jam jar. Ted Danson is on crutches knocking out amyl nitrate from a suitcase to Greg Wallace who is dressed as Charlie Brown. Greg has webbed hands and a badge on his jumper that says 'Always keep your Basil's straight'. The fiercely competitive battle is taking place in Ken Dodd's mouth.

Thanks,

Serge

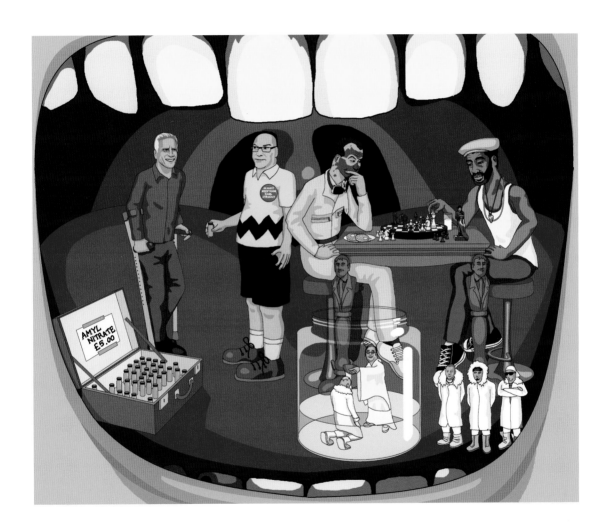

A topless, and recently tortured, Piers Morgan in the wicker chair from Emmanuel *reading the sole charred copy of* The Elephant and the Balloon *from Black Books to a crowd of baby geese with John Terry's face*

As requested by Ben

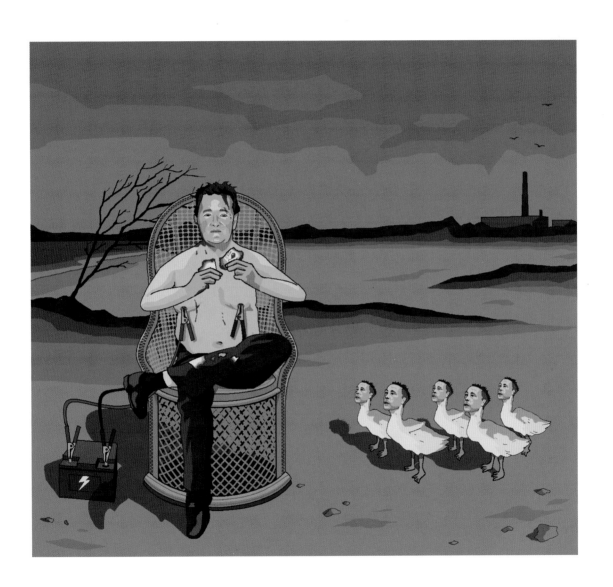

Barry Scott overdosing on Cillit Bang

As requested by Sam

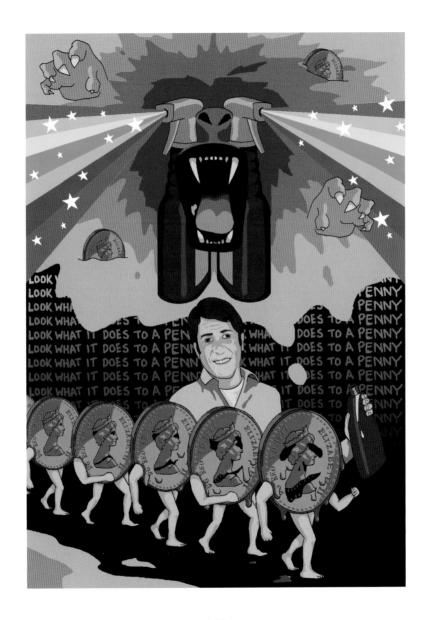

Boris Johnson fighting off an alien invasion

As requested by Dean

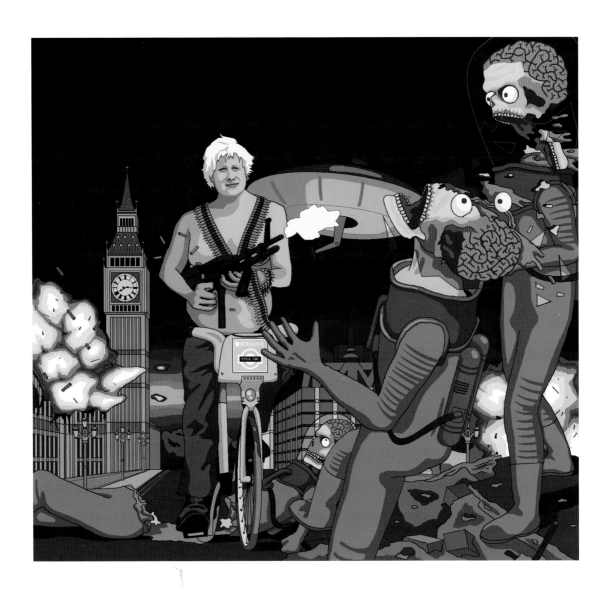

Dear Jim,

Please paint a David Lynch mob. That would be swell.

Thank you,

Jonathan

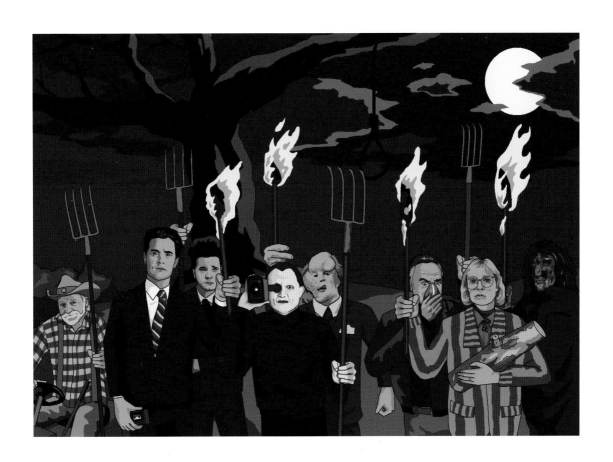

Dear Jim,

This happened recently in a little town called Barnstaple, Devon:

Link to a North Devon Journal *article about a drunk man who set fire to a packet of peanuts and tried to make love to an ambulance.*

Please paint me what happened in this story.

It would make my life,

Claudia

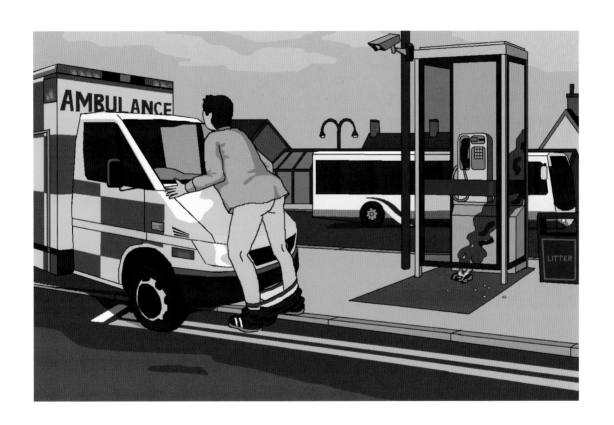

The Chuckle Brothers recreating the pottery scene from Ghost *only the pot is the Lionel Richie head from the 'Hello' video.*

As requested by Russel

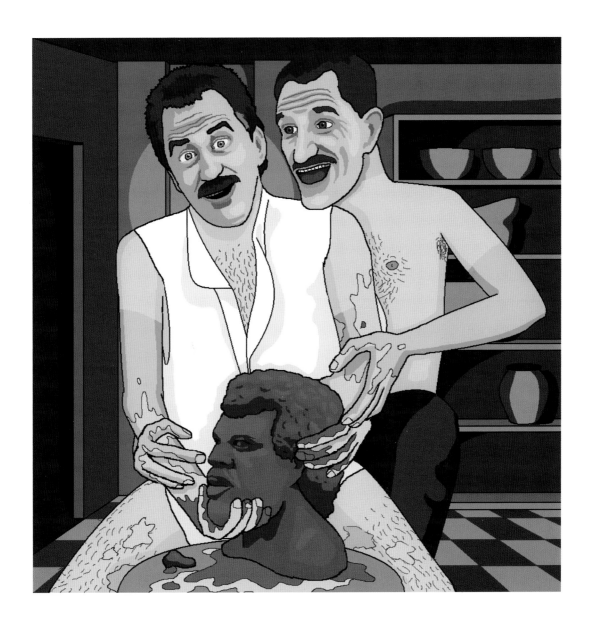

Dear Jim,

Please paint me Andi Peters getting his hair cut by the strange creature with eyes on its hands out of Pan's Labyrinth.

Thanks,

Bubble-Shooter

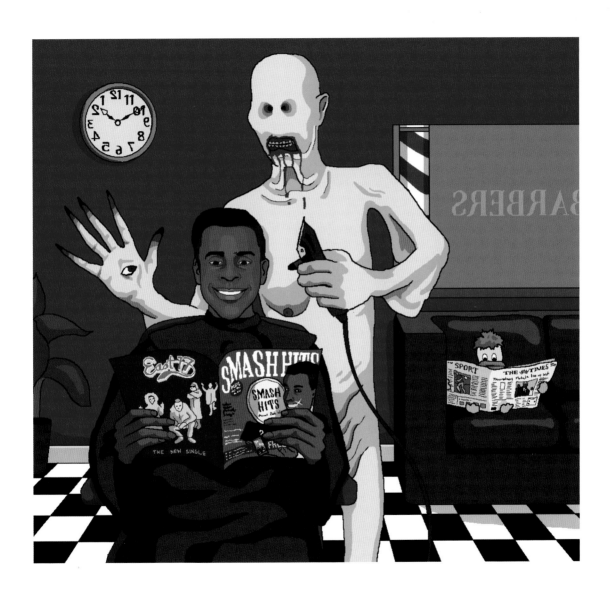

Morrissey Ruins Christmas

As requested by Paul

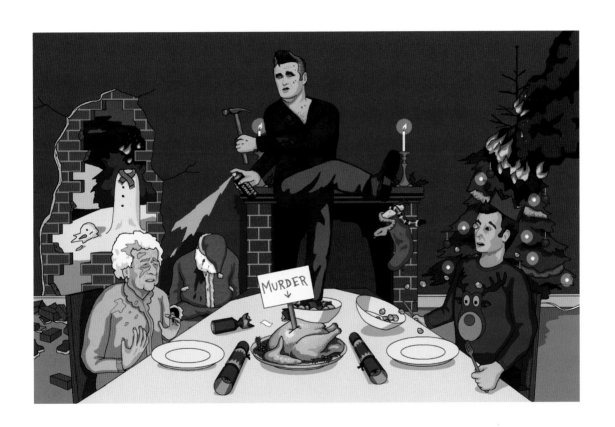

Dear Jim,

Please paint me Thom Yorke wrestling Mr. T in the facility bathroom from Goldeneye *for the N64.*

Godspeed.

Zachariah

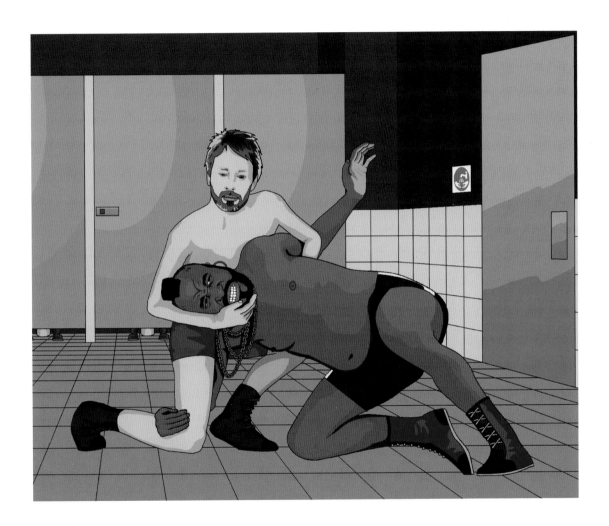

Dear Jim,

Please paint me Moby throwing ninja stars at a melancholic badger whilst eating a Papa John's pizza in Lidl in Shrewsbury. Moby is wearing an Admiral England shirt, Bermuda shorts and eighteen-hole DMs. The badger is sat in Spielberg's director's chair and smoking a pipe.

Thanks,

postrockowl

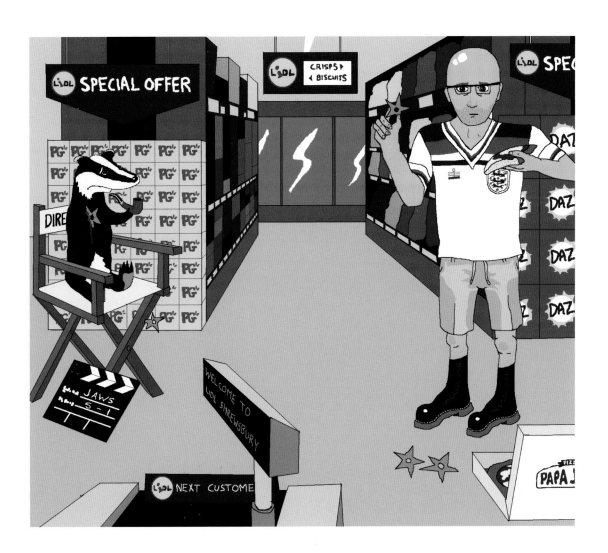

Dear Jim,

Can you please paint for me Rolf Harris in the Colosseum, holding his wobble board and shouting to the crowd 'Are you not entertained?!' The crowd, meanwhile, is represented by 80,000 Joey Tribbianis, from the Friends *episode where he had a turkey stuck on his head.*

Many thanks,

Alex

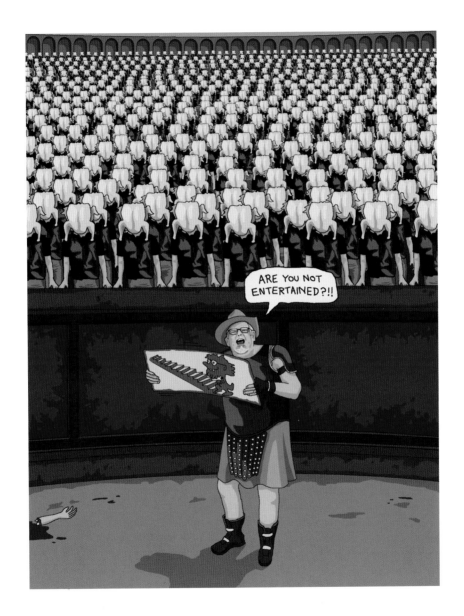

Hi Jim,

Please paint me Orville and Dean.

Many thanks,

Luke

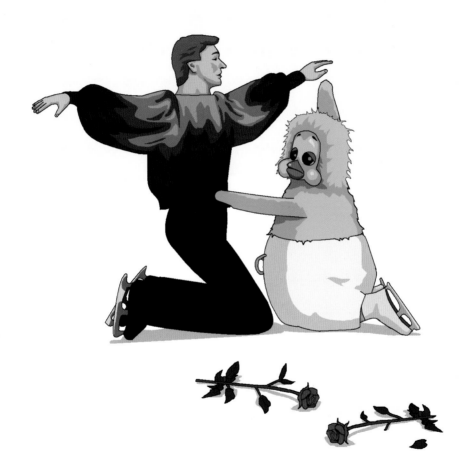

Zombie Jesus birthday party

As requested by Adam and Dan

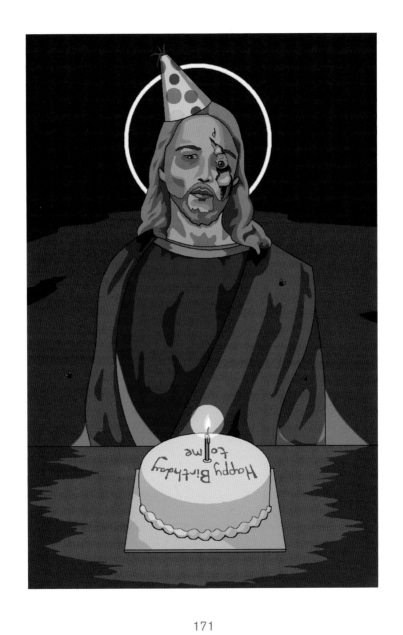

Dear Jim,

Please paint me a picture of Ted Danson and a Ted Danson lookalike. They're covered in bruises after getting into a fight over who the real Ted Danson is. They've made friends now though and are posing for a photograph at the chicken rave where they've been for a night out. Moira Stewart is standing behind them, looking on disapprovingly.

Thank you.

bruteforsythe

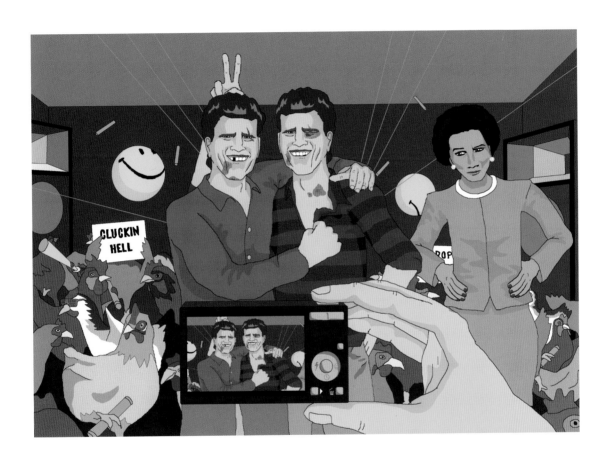

Dear Jim,

Can you please paint Dave Benson Phillips riding a goose into battle.

Cheers,

Callum

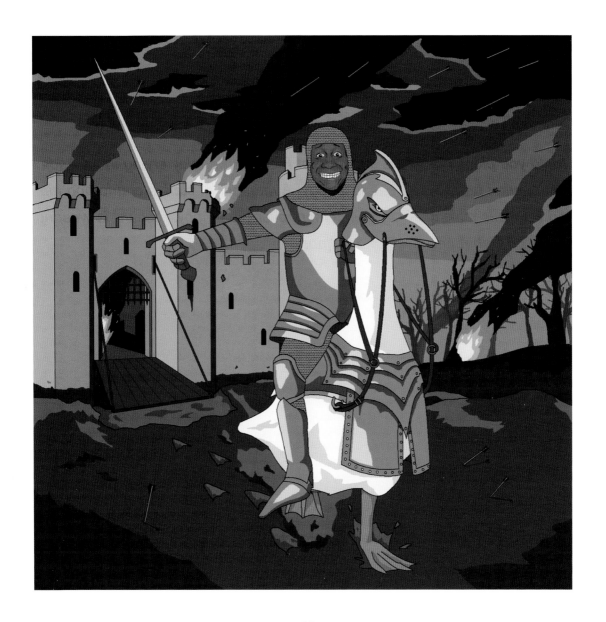

Dear Jim,

Could you please paint me a picture of Richard Madeley crying in an Asda supermarket because he has lost Judy. A member of staff is comforting him and Prince is making an announcement over the tannoy. Richard is wearing a Ben 10 T-shirt and holding a balloon.

Cheers,

Alistair

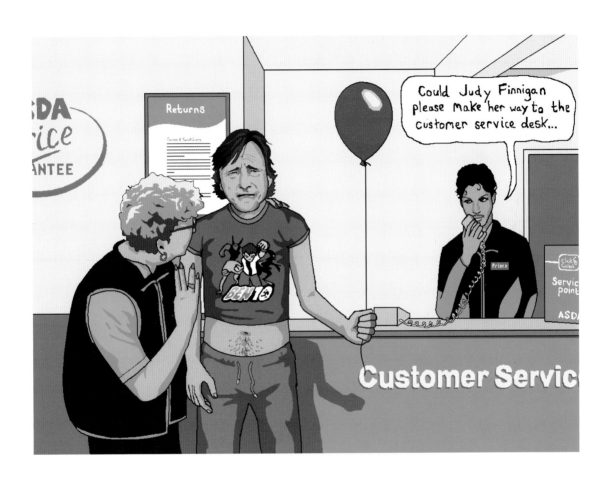

'Woman in sumo-wrestler suit assaulted her ex-girlfriend in gay pub after she waved at man dressed as a Snickers bar'

Taken from a genuine *Daily Telegraph* headline and requested by Michael, Marie and lots of other people (sorry if I've missed you)

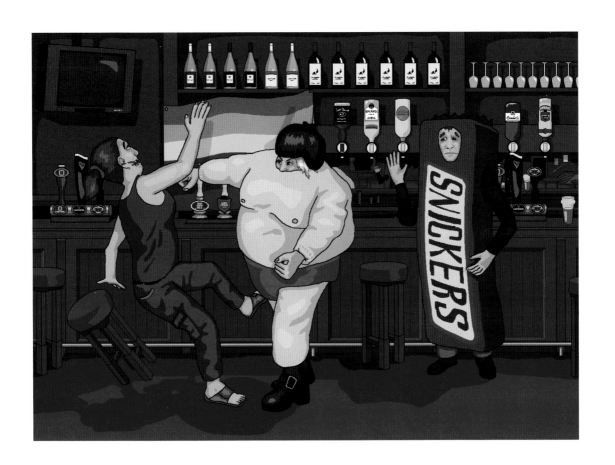

A lovely picture of the Queen

As requested by Paul

The one above was deleted by Facebook and the one below was offered as a substitute after my twelve-hour ban.

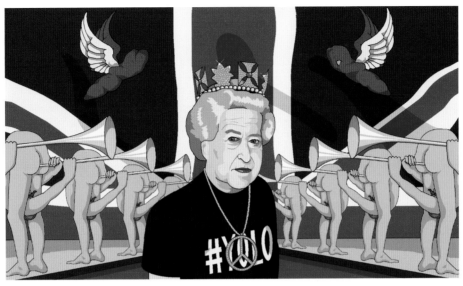

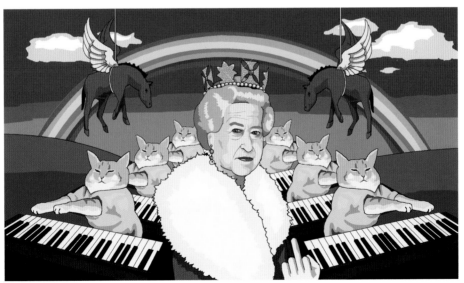

Brian Blessed punching a polar bear in the face

As requested by Emily and Lyam

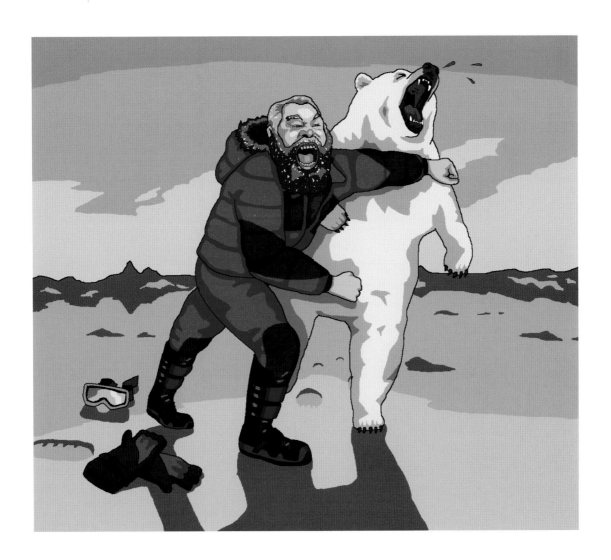

Larry David as a superhero

As requested by Sarah

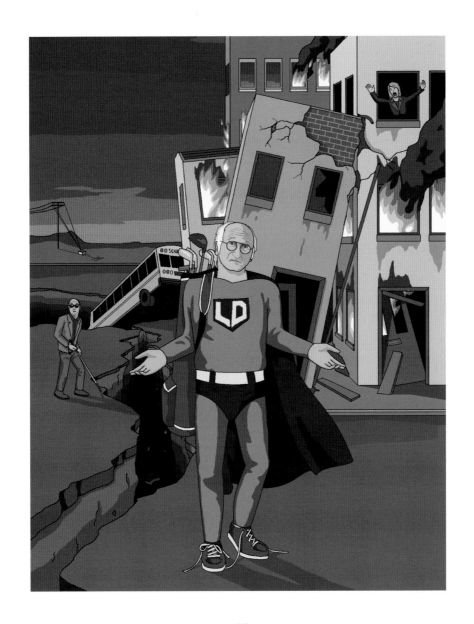

Dear Jim,

Please can you paint for me a picture of Ed Miliband wearing the Wrong Trousers walking down James Turner Street being whipped by Jo Brand in erotic lingerie shooting rainbow laserbeams out her nipples and Cliff Richard in a Lacoste tracksuit drinking Skol Super with White Dee.

Cheers,

Adam

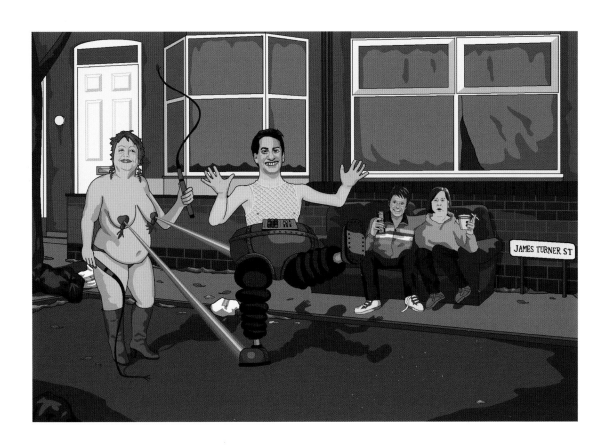

187

Dear Jim,

Someone at work told me today that Bob Holness didn't really play the saxophone on Gerry Rafferty's 'Baker Street'. Please use your Microsoft Paint skills to make my shattered illusion a reality.

Cheers,

Will

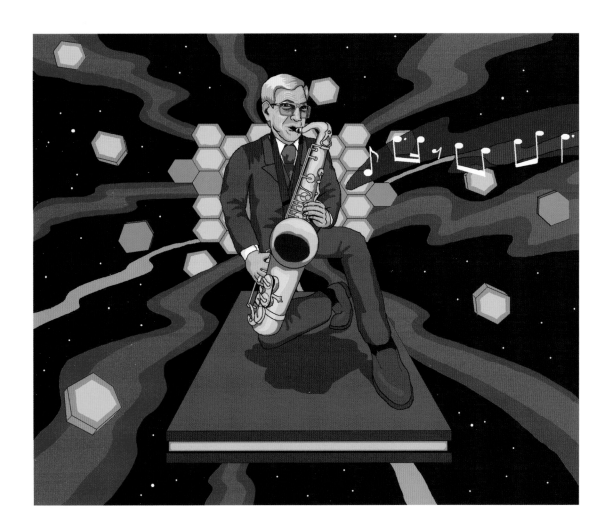

Carry on Raving (the illegal gabber techno/stack worship variety)

As requested by Angus

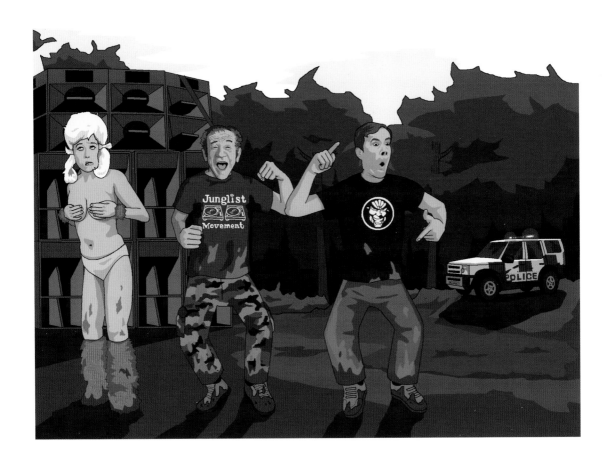

Jeremy Paxman for sale in a vending machine

As requested by Laura

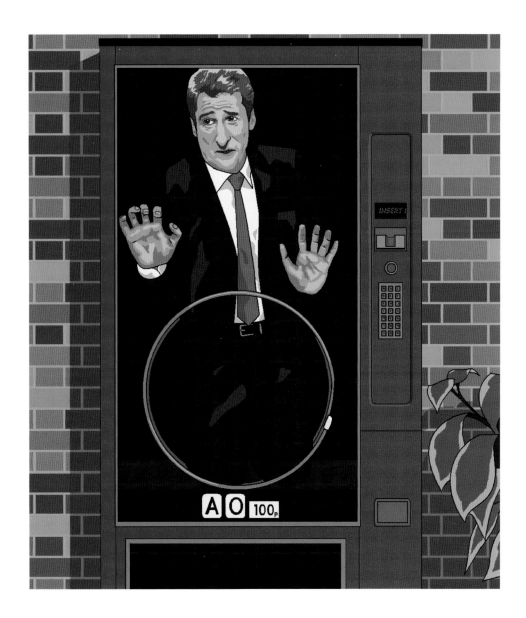

I want to see Uncle Phil from The Fresh Prince of Bel-Air *dressed as Shredder from* Teenage Mutant Ninja Turtles *walking through the gates of heaven, high-fiving Saint Peter.*

Thank you Jim.

Invokal Poet MC

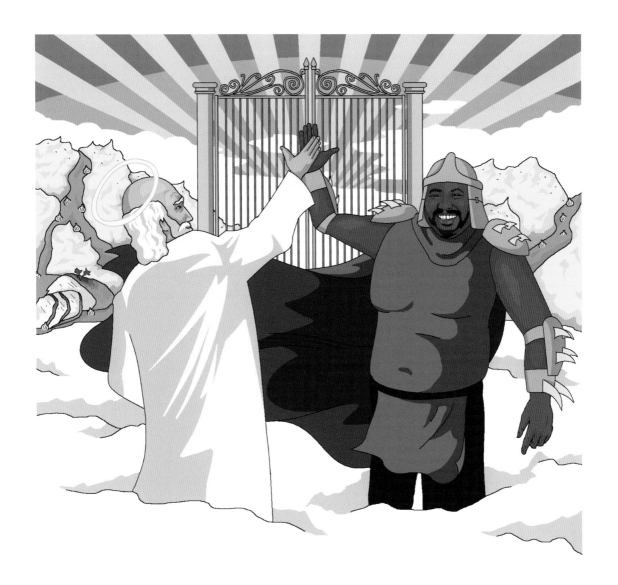

Dear Jim,

Please paint me Ann Widdecombe riding Space Mountain.

All the best,

Adam

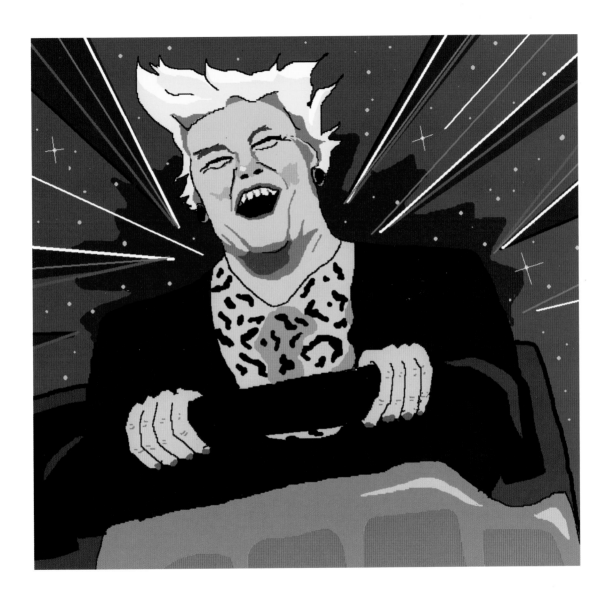

Dear Jim,

Please do an Oscar®-style selfie with UK 'celebs' from the nineties. I'll let you pick.

James

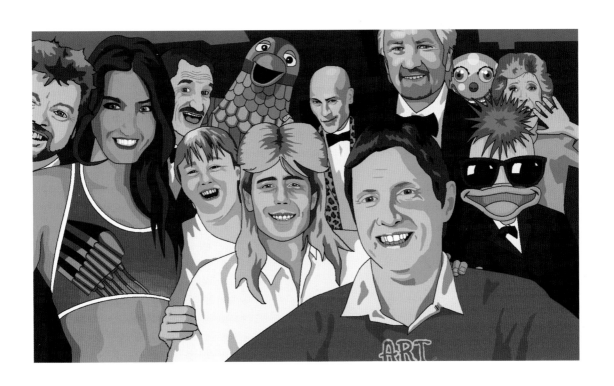

Dear Jim,

Please can you paint me Jim Bowen and Bully making a break for it in the Bullseye speedboat . . . perhaps in a Thelma & Louise*-style leap to freedom?*

Thanks,

Matthew

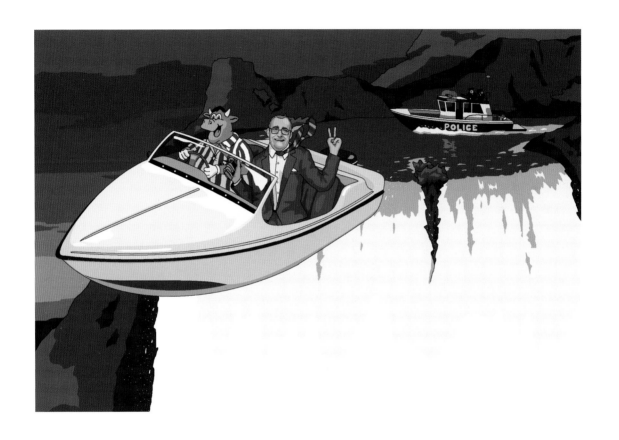

ACKNOWLEDGEMENTS

Huge thanks to the ever-cheerful Andy Miller for making this book happen and for always taking time out to hold my hand through the slightly overwhelming process of bringing these images into the real world. I owe you one. Thanks also to Julian Loose, Kate Ward, John Grindrod, Alex Kirby, Donna Payne and everyone at Faber for the generous quantities of enthusiasm, hard work and support.

Thanks to Nags for inspiring me to spend my lunchtimes doodling, Dom Smartphone for persuading me to start a Facebook page, my lovely mum for sharing every single one of my paintings no matter how offensive and Brian Blessed for being a good sport and a generally brilliant human.

Thanks also to Lee Johnson, Dean Ayotte, Jessica 'TourettesHero' Thom, Tom Jenkins, 1Click Nathan, Andy Stewart, Geraint Davies, Rob Alderson and all my friends and family who have supported me through the weirdest year of my life. You've been awesome.

Special thanks to my wife-to-be, Natalie, for her tireless support, unconditional love and for putting up with fifteen months of me sitting in my pants drawing pictures while she gets up every morning to go and do a proper job. I just wouldn't cope without you.

Thanks, finally, to the thousands upon thousands of people who delved into the darkest corners of their imagination to provide me with quite possibly the largest database of surreal ideas ever compiled. Please, please keep them coming.

facebook.com/jimllpaintit | jimllpaintit.tumblr.com | jimllpaintit.bigcartel.com